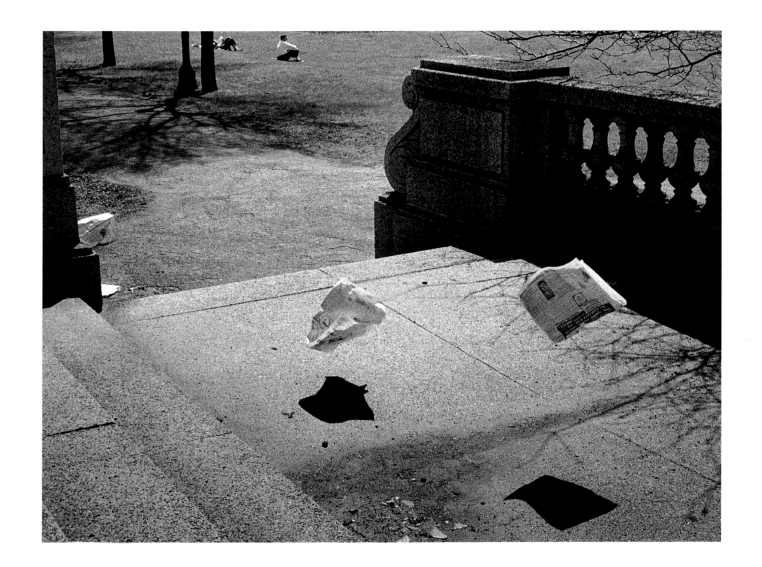

YASUHIRO

COLIN WESTERBECK

With contributions by

ARATA ISOZAKI and

FUMINORI YOKOE

ISHIMOTO

A TALE OF TWO CITIES

THE

ART INSTITUTE

OF CHICAGO

This book was published in conjunction with the exhibition "Yasuhiro Ishimoto: A Tale of Two Cities," organized by The Art Institute of Chicago and presented from May 8 to September 12, 1999.

The exhibition "Yasuhiro Ishimoto: A Tale of Two Cities" was sponsored by American Airlines. Generous support for the exhibition was also provided by Annie Properties Fund and Canon, with additional funding from Sata Corp. and the Focus Infinity Fund. This book was made possible in part by Toppan Printing Company, Ltd.

First Edition

Printed in Japan

Published by The Art Institute of Chicago,
111 South Michigan Avenue,
Chicago, Illinois 60603-6110

Distributed worldwide by the
University of Washington Press,
P.O. Box 50096,
Seattle, Washington 98145-5096
1-800-441-4115

Edited by Robert V. Sharp, Associate Director of Publications, The Art Institute of Chicago

Production by Amanda W. Freymann, Associate Director of Publications–Production, The Art Institute of Chicago

Designed by Carl Zahn and typeset by Carl Zahn and Frances Presti

Printed and bound by Toppan Printing Company, Ltd., Tokyo

Front cover: Chicago, 1959/61
Back cover: Tokyo, 1994

Library of Congress Catalog Card Number: 98-89749
ISBN-0-86559-170-9

CONTENTS

FOREWORD

Yasuhiro Ishimoto has given The Art Institute of Chicago a donation of his work that does great honor not only to our museum, but also to the city of Chicago. Through the photographs he has made, primarily during two intense periods of work and residence in Chicago, Ishimoto has created a documentation of this city that only one or two other urban areas of the country could match. The photographs themselves are Ishimoto's gift to the Art Institute, but the vision of Chicago that they contain is his gift to the city as a whole. The accuracy of his observations combined with his great generosity of spirit toward the city and its inhabitants makes his work a unique testimonial to Chicago.

But it is not our perception of Chicago alone that is enhanced by this donation, for it also contains a large body of work depicting Ishimoto's home city of Tokyo. Between these two cities and the two cultures that they represent, Ishimoto's photographs build a bridge that spans a hemisphere. The magnitude of Ishimoto's accomplishment was recognized recently in his homeland when he was made a "Person of Cultural Merit," an honor that entails a fellowship for life. Only the most distinguished Japanese artists have this award and its accompanying fellowship granted to them by the nation. Now it is our turn to celebrate Ishimoto's lifetime achievement by means of a full-scale retrospective, the highest form of recognition a museum can bestow.

While a significant part of Ishimoto's earlier American work is known in this country, and in Chicago particularly, the decades that he has spent photographing in Japan have scarcely been explored. That this exhibition brings us up to date with the photographer's career makes it an enlightening experience for our audience. That the contents of the exhibition have been donated to the photography collection makes it a permanent benefit to the Art Institute. We offer our sincerest thanks to Mr. Ishimoto not only for making this generous gift to our museum, but, most especially, for having enormously enriched the art of photography.

James N. Wood, Director and President
The Art Institute of Chicago

ACKNOWLEDGMENTS

The generosity of spirit apparent in the photographs of Yasuhiro Ishimoto has been matched by the photographer's further generosity to The Art Institute of Chicago in offering a donation of prints representing his entire career. We were, fortunately, in a position to build on strength in accepting his offer. Among the Chicagoans who have been collecting work by Ishimoto going back to his student days at the Institute of Design, the following had already made key donations to the Department of Photography: the late Mary Morris Diamond Stein, Jack and Bobby Jaffe, and David C. and Sarajean Ruttenberg. To these generous and farsighted patrons we owe our first debt of thanks.

Jack Jaffe and the Focus Infinity Fund also have our gratitude for having underwritten some of the travel necessary to the project. One by one, other sponsors have stepped forward with support as well. From Tokyo came commitments from both the Sata Corporation and, for the production of the catalogue, Toppan Printing. Then the Annie Properties Fund of Chicago made possible a project assistant, and Canon U. S. A. also offered funding. Most crucially, American Airlines agreed to be the primary sponsor that has allowed us to bring our three-year project to fruition.

In Tokyo, the staff of Photo Gallery International, and especially gallery manager Shin Yamazaki, were unstinting in their efforts to help. At the Art Institute, a variety of staff members in the Department of Photography have made important contributions to the success of this project. The key task of special-project assistant has been shared by two people, Jennifer Jankauskas and Margaret Denny, each of whom kept admirable, accurate track of the endless details involved. The department's Collection Manager, Kristin Merrill, oversaw the large number of prints by Ishimoto that had to be accessioned, and Department Secretary Lisa D'Acquisto handled much of the paper work.

Comer Foundation Intern Seth Almansi provided valuable research help in the early stages, as did Christine Starkman, formerly of the Art Institute's Department of Asian Art, during preparations for a 1997 exhibition of Ishimoto's documentation of Ise. Ms. Starkman also provided essential aid by translating various documents from Japanese. As always, Preparator Jim Iska did the matting and framing with great efficiency, and Conservator Doug Severson, ably assisted by Mellon Foundation Intern Sylvie Penichon, monitored the condition of the many Ishimoto prints being handled by the department.

Curator of Photography David Travis was an invaluable advisor on matters ranging from funding to the catalogue. He and Associate Curator Sylvia Wolf both acted as readers of the catalogue's primary essay, which was improved enormously by their suggestions. Beyond the Photography Department's own staff, that of the Publications Department was essential to creating the catalogue. Robert Sharp edited the texts for the catalogue with his customary grace and forbearance, while Amanda Freymann contributed to this book not only by managing its production with great care, but by inviting designer Carl Zahn to lend his renowned talents to our project.

Finally, there were four people—two in Japan and two in the United States—who made an important intellectual contribution to the project. From Tokyo, architect Arata Isozaki and curator Fuminori Yokoe sent us essays for the catalogue that shed invaluable light on Ishimoto's career. In this country, Institute of Design graduate Joe Sterling shared his remembrances of Ishimoto, and Ishimoto's classmate at the I. D., Marvin Newman, remastered on video a student film he and Ishimoto made entitled *Maxwell Street*. Through Mr. Newman's efforts, we have been able to make the film available for viewing during the exhibition.

Colin Westerbeck, Associate Curator of Photography
The Art Institute of Chicago

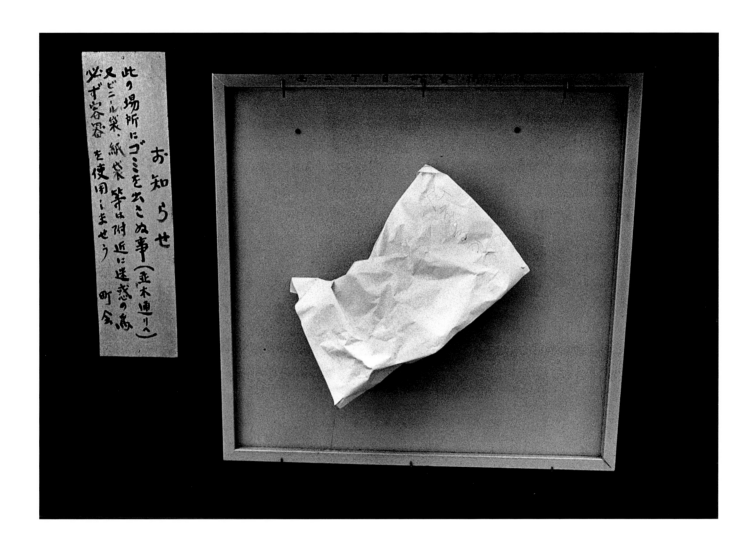

Chicago, 1959/61

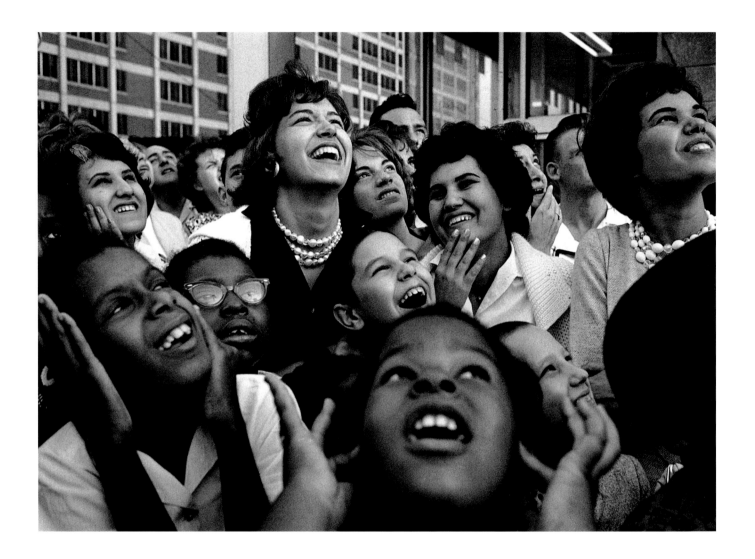

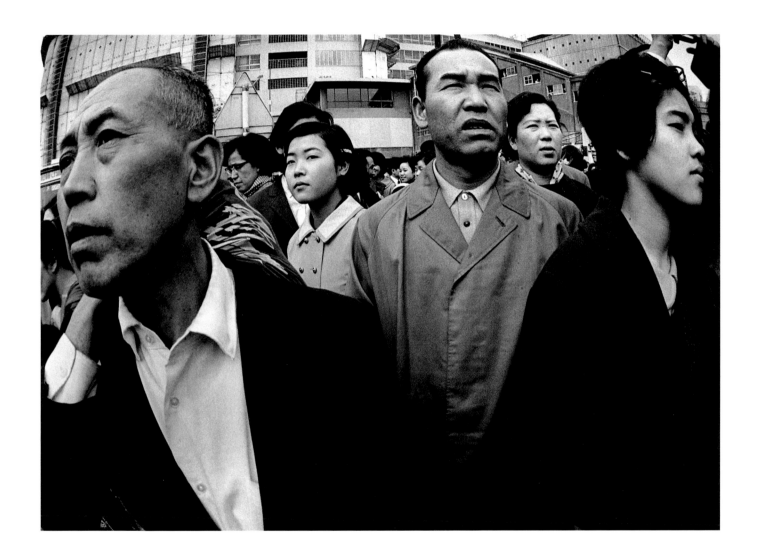

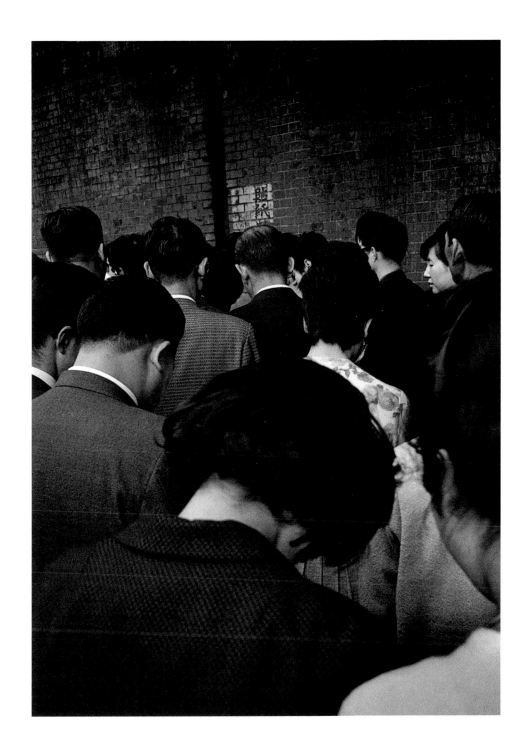

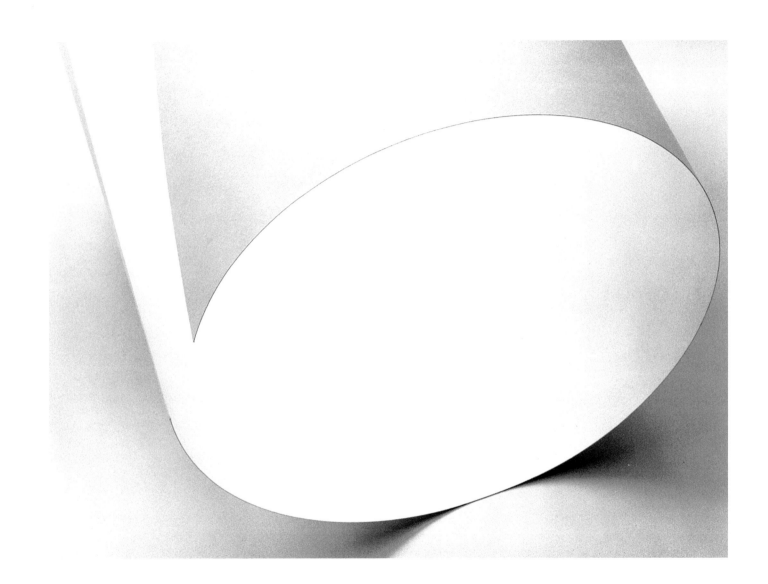

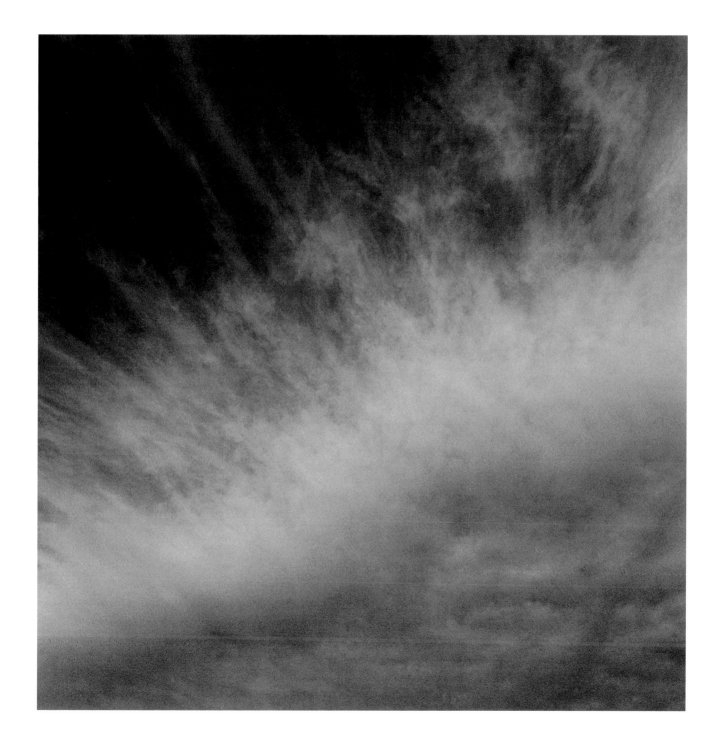

Tokyo, 1988

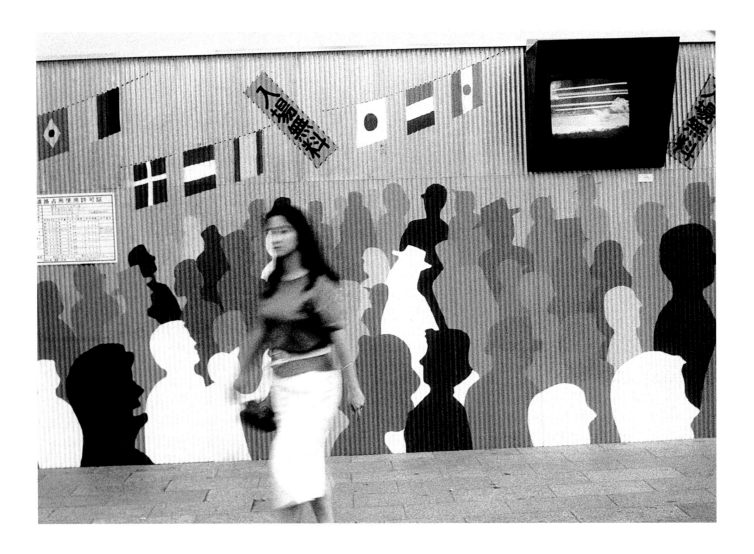

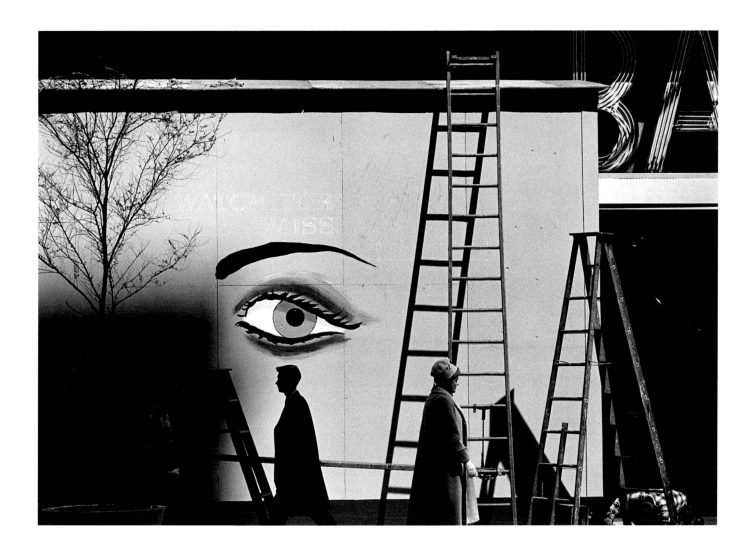

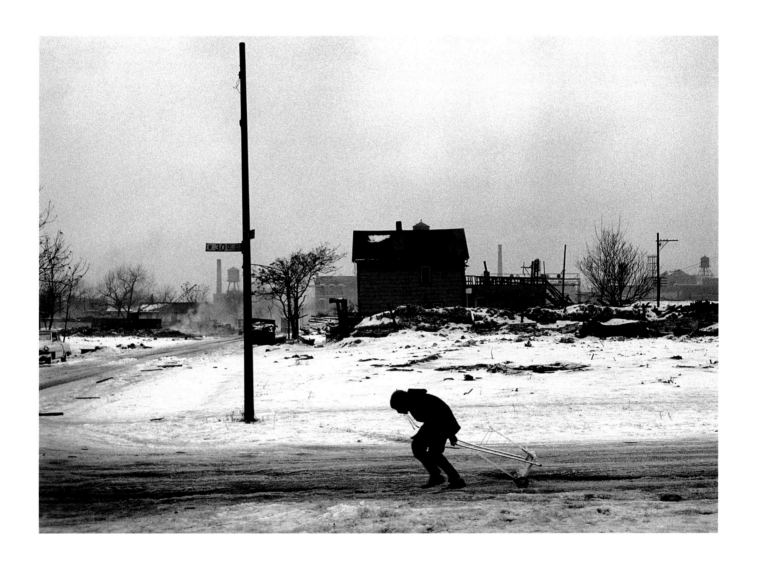

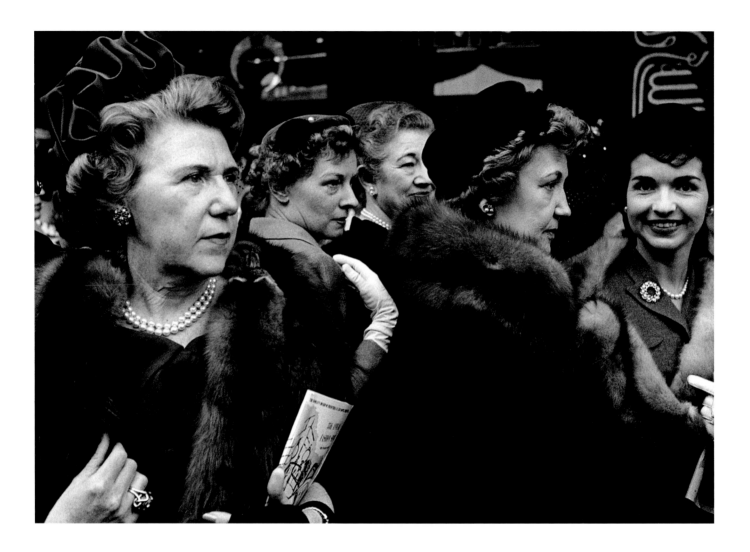

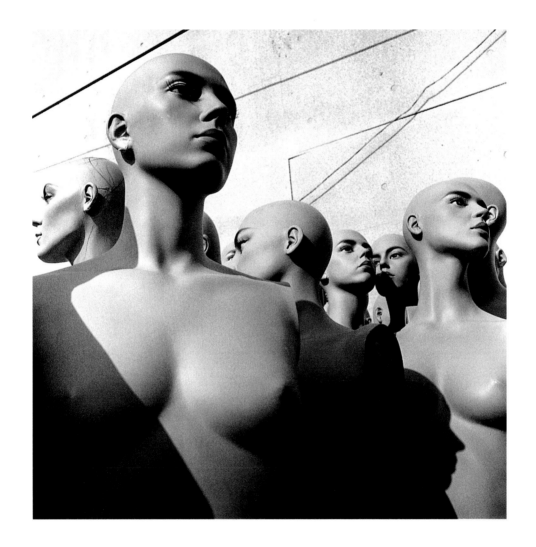

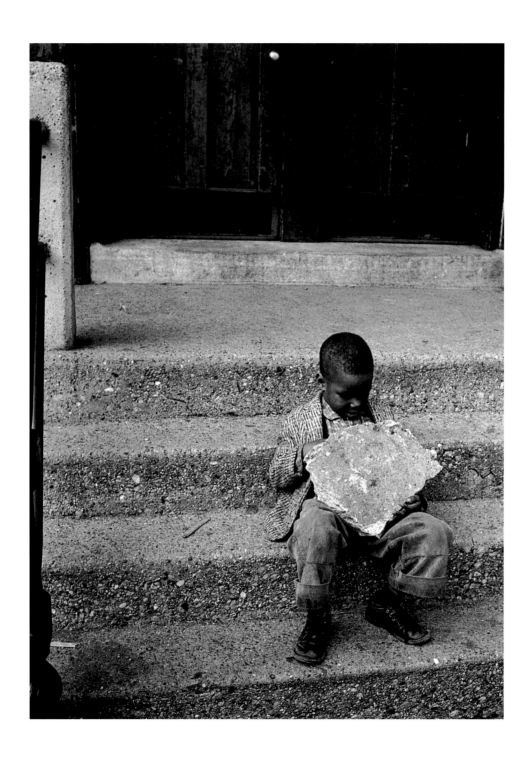

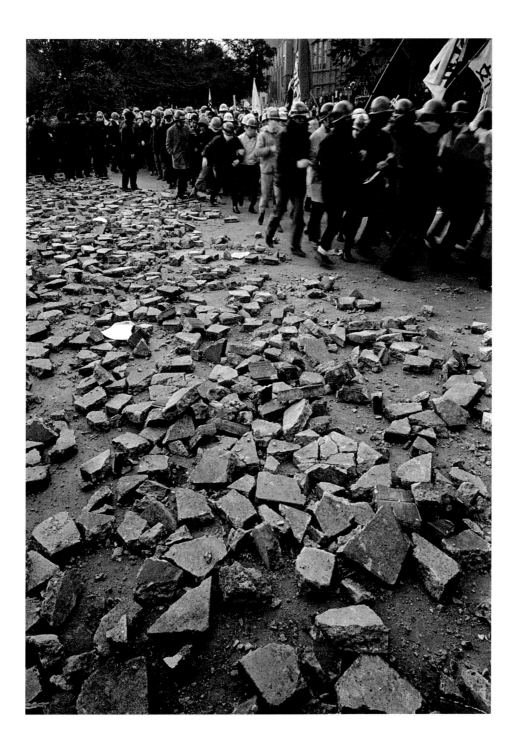

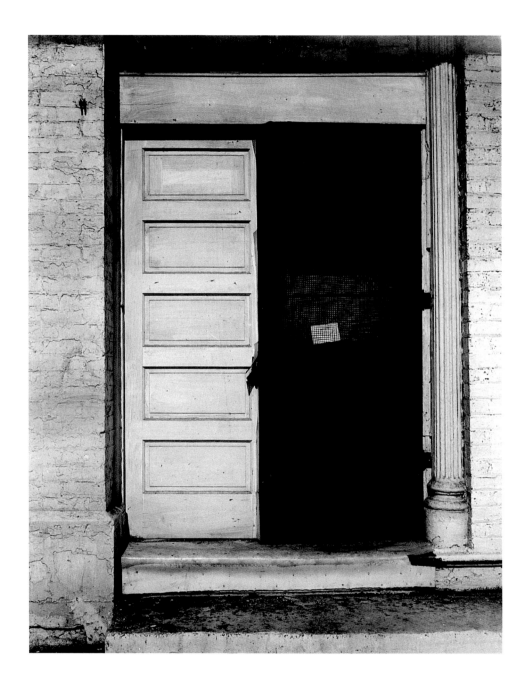

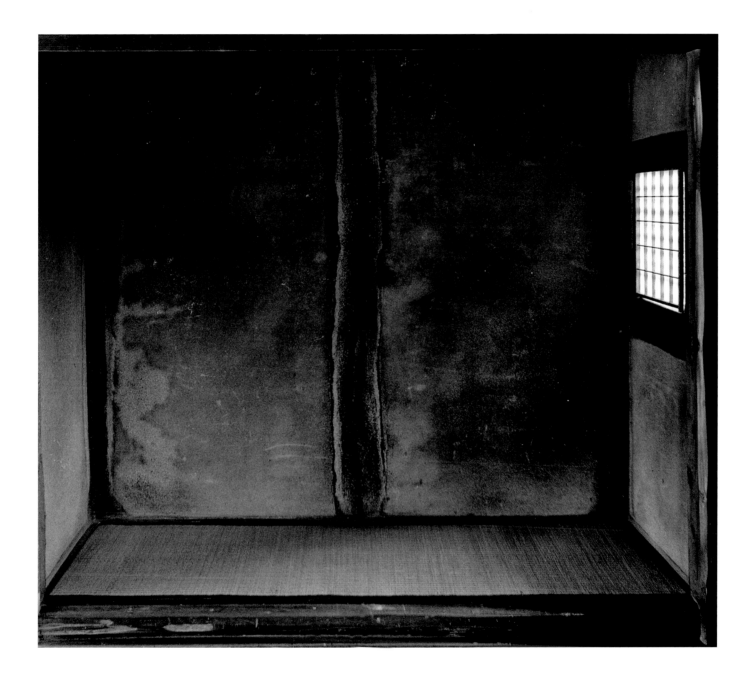

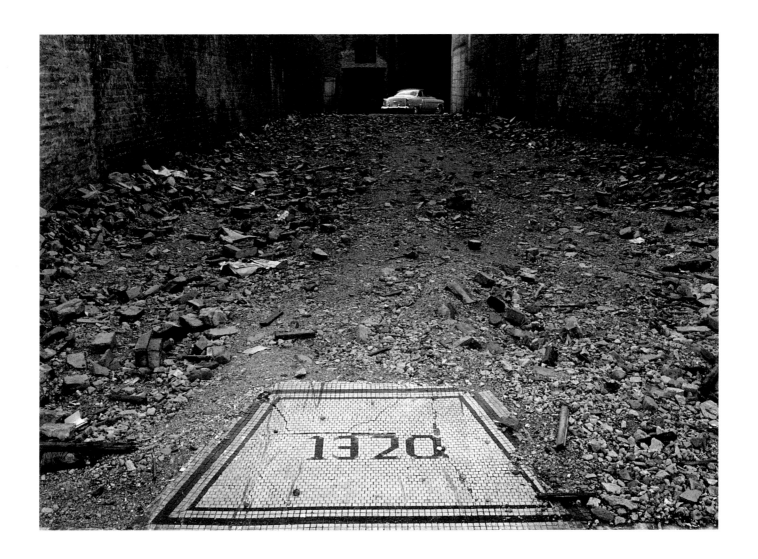

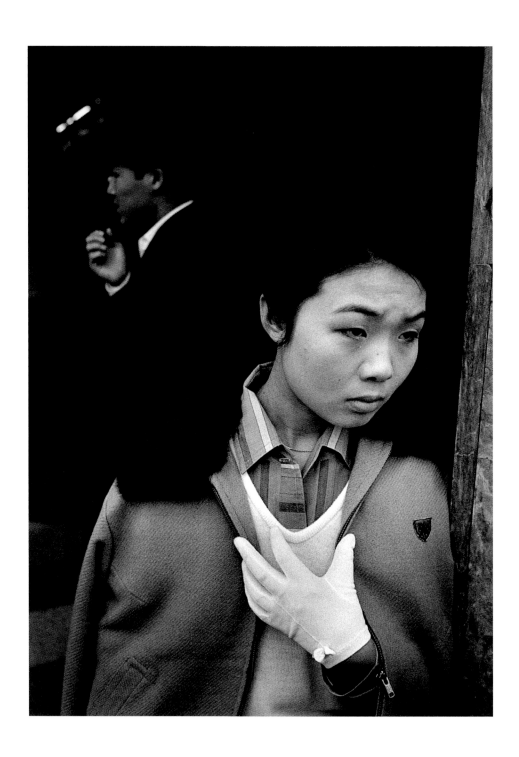

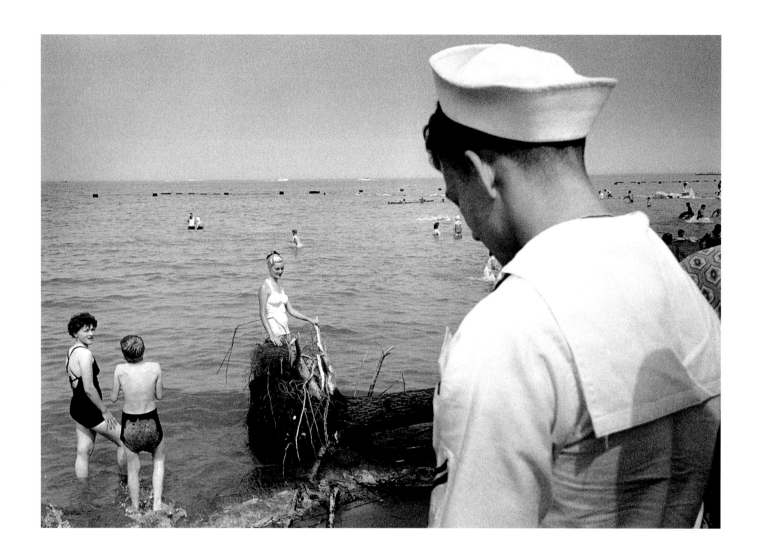

Tokyo, 1953

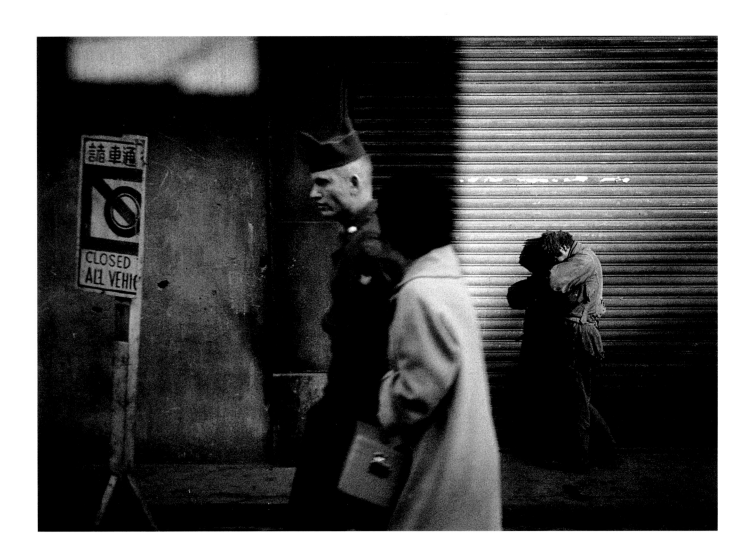

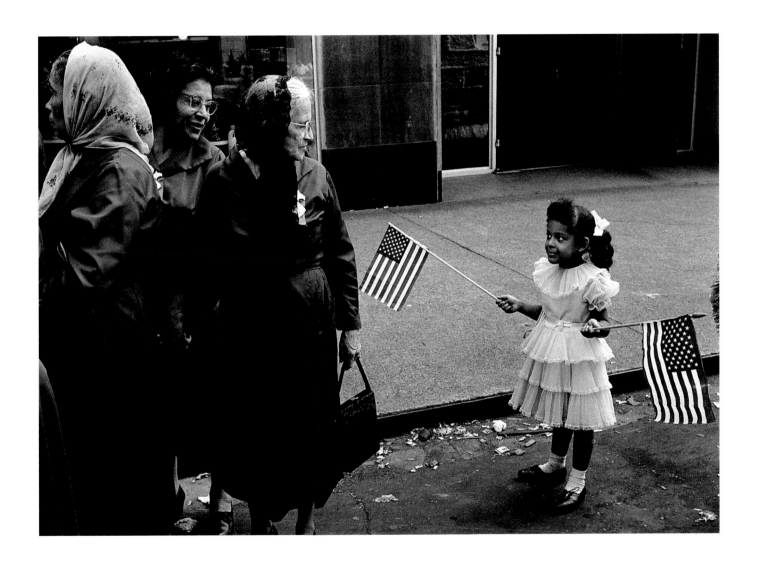

THE TEN FOOT SQUARE HUT

COLIN WESTERBECK

Stories of great men often begin with a journey, and Yasuhiro Ishimoto has lived many stories in his time and taken many journeys. He has retraced the route of Islam from Cordoba, Spain, across the subcontinent of Asia to Fatephur Sikri, India, and then to Hsi-an, China.[1] He has made a pilgrimage to Japan's most sacred Shinto shrine, Ise, which took him decades to reach though it is only a few hundred kilometers from his home.[2] He has circumnavigated Tokyo for years on the Japan Rail line, getting off to photograph at all twenty-nine stops as if they were the fifty-three stations of the Tokaido road. He has traveled from Tokyo to Chicago and back again, several times. This last journey is the story I ultimately want to tell here, but the essay begins with yet another journey—a sentimental one Ishimoto undertook recently from Tokyo to Kyoto to visit again Katsura Rikyu. Built by Prince Toshi-hito in the early 1600s, this villa provided the subject matter with which Ishimoto first made his reputation as a photographer in his own country over forty years ago.

At that time, Ishimoto was newly returned after a fourteen-year absence in America, where he had received his education as a photographer in Chicago at the Institute of Design, the school that had grown out of Germany's Bauhaus. While he was still a student there, Harry Callahan, his teacher at the I.D. (as the Institute of Design was known), had brought Ishimoto's work to the attention of the most important photography curator of the day, Edward Steichen, at New York's Museum of Modern Art. Besides offering the young photographer an exhibition, Steichen would put two of Ishimoto's photographs into his 1955 magnum opus, *The Family of Man,* and he would visit Ishimoto in Japan when the show traveled to that country the following year. Meanwhile, however, Steichen asked Ishimoto to squire the Modern's architecture curator, Arthur Drexler, around Japan during a trip Drexler made there in 1953, the year of Ishimoto's return.

At the top of the curator's agenda was a tour of Katsura Villa that had to be arranged through the imperial household. Ishimoto may have had difficulty getting access to a sacred shrine like Ise, but he had the right postwar credentials to gain access to a secular one like Katsura—an American passport. (Having been born in San Francisco in 1921, Ishimoto was an American citizen. But that's yet another story.) When Ishimoto, who had never been to Katsura himself, arrived with Drexler at this seventeenth-century complex of buildings, he had a revelation of the famous landmark as a supreme work of modern architecture.

In order to demonstrate the impact that his first sight of Katsura had on him, Ishimoto will dig out of a cabinet in his living room a brochure that he brought back from Chicago in 1953. Though he had had nothing to do with creating this little pamphlet, Ishimoto had saved it out of fascination with the real-estate development for which it was a promotion—the construction of twin high-rise apartment towers at 860–880 North Lake Shore Drive designed by Mies van der Rohe. Turning to a photograph of the two buildings, Ishimoto holds his hand across their upper floors, so that each building is seen as a low structure of white panels framed by vertical black I-beams rising from ground level. "Katsura," Ishimoto says simply, and what he's getting at is obvious.[3] Mies's design looks exactly like the famous villa on which vertical supports in dark wood rise to frame *shōji* screens and white walls (see fig. 1).

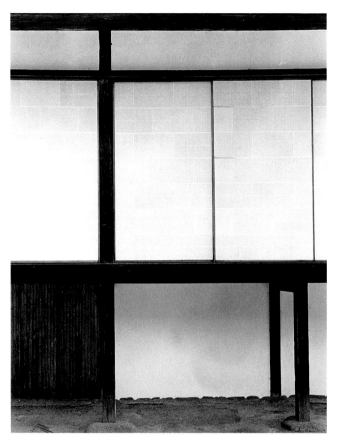

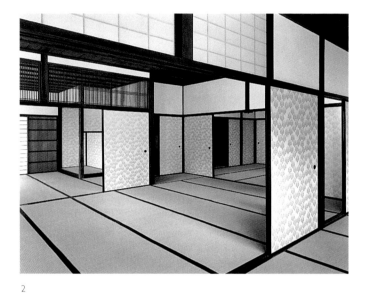

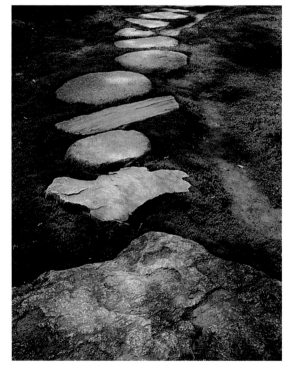

Fig. 1. Katsura Villa, 1954

Fig. 2. Katsura Villa, 1954

Fig. 3. Katsura Villa, 1954

After the trip to Katsura with Arthur Drexler, Ishimoto brought a few photographs he had made at the villa to show to Japanese architect Kenzo Tange, whom he had met through another of his American connections. Did Tange think there was a book in this subject if it were photographed this way? The architect readily understood the point of Ishimoto's pictures, and he recognized how well they fit with his own idea about the villa. Together they approached a publisher, who hired designer Herbert Bayer to lay out the book and commissioned architect Walter Gropius to write an essay complementing Tange's. Gropius and Bayer had both been associated with the original Bauhaus in Germany and had contributed to a book that had inspired Ishimoto as a student.[4] From the photographer's point of view, the two men were therefore welcome additions to the project. The book on Katsura took shape as an East-meets-West collaboration, one for which Ishimoto served not only as originator, but as a synthesis of Tange's Japanese background with Gropius and Bayer's Bauhaus point of view.[5]

By seeing Katsura as proto-modern architecture, Ishimoto and Tange helped in the effort to reinvent Japan as a late-twentieth-century nation. They joined other artists and intellectuals who were attempting to pull their country out of the xenophobia, the near return to feudalism, that had led to the catastrophe of the war.[6] Tange's essay is a polemic that does this in part by arguing that Katsura shows the influence of the common domestic buildings of its day as well as imperial architecture. He sees in the villa two conflicting principles that represent both the refinements of an elite and the simple energy of common life: "Close study has led me to see in Katsura both an aristocratic tendency to preserve or recapture the tra-

dition of the Heian court and an anti-aristocratic tendency to create something entirely new." Tange asserts that in Katsura "the cultural formalism of the upper class and the vital energy of the lower class met. . . . Katsura Palace represents in a sense the rising prestige of the common people." He concludes his essay with the contention that "we of the present age are faced with the same dialectic of tradition and creation that Katsura exemplifies."[7]

This argument democratized the villa; it made an ancient monument seem accessible to a people accustomed to approaching such historical sites with extreme deference. And in a way that is subtler than Tange's text, Ishimoto's photographs accomplish something similar by giving the structures, and most particularly the main buildings, or *shoin*, a contemporary feel. His viewpoints were chosen to avoid decorative detail and present Katsura as the type of graphic and abstract space that the introduction of the "International Style" in architecture was then beginning to make familiar in Japan (see fig. 2).

Nowhere has the effect of Ishimoto's Katsura work been summarized more clearly than in an essay on the photographer written by Ikko Tanaka, the art director of the Japanese magazine *Approach*. Speaking of others in design and the visual arts who, like himself, grew up in the postwar period, Tanaka wrote, "Who of us could ever forget the powerful impact Ishimoto's photos of the Katsura Villa had on us in the 1950s? The collection was much talked about at the time. . . . After seeing just two or three of Ishimoto's photos I, and many like me, was completely won over. Naturally, we were captivated most by the photographer's rediscovery of Japanese beauty. Yet we were also overwhelmed by his phenomenal sense of

'design.'. . . In Ishimoto's photos we found . . . an intellectu-
al and austere modernism that encouraged us greatly. . . .
[Ishimoto's images] brilliantly displaced the tepid senti-
mentalism . . . long characteristic of Japanese cultural
expression. His *shōji* windows were partitioned in the
manner of Mondrian. His garden steppingstones resem-
bled a Brancusi sculpture. Through the quintessentially
concrete medium of photography, Ishimoto set the world
in an all-new perspective." [8]

The actual photographs for the Katsura book were made
the year after the visit with Drexler, when Ishimoto was
permitted to return to the villa for one month to docu-
ment the buildings and the gardens. Having no assistant,
he had to enlist the aid of one of the gardeners to hold
his reflector for him as he set up his shots. Restrictions
on his project imposed by the imperial household com-
pelled him to work without a break from 9:00 until 4:30
everyday, and afterwards, famished, he would head for a
little tea house across the road from the grounds of the
villa. The tea house is still there, and when Ishimoto
entered it during his recent return to the area, the elderly
proprietress exclaimed with joy at seeing him again. She
could hardly have been more than a girl when first he
visited.

Only returning to Katsura with Ishimoto could reveal to
me the full significance of his original trips there. As the
Shenkansen, Japan's famous bullet train, flashed across the
countryside on the run from Tokyo to Kyoto, Ishimoto
reminisced about his earlier trips. What once took eight
hours the Shenkansen covers in two and a half. On the
other hand, the view out the window was more scenic
then, Ishimoto recalled. The low-lying mountains shrouded

with mist—the classic subject matter of Japanese land-
scape painting—remain, of course, but the foreground is
now the sort of industrial backyard one sees from trains
everywhere. Only here and there do you catch sight of
the tea plantations that once dominated the region,
though it is still an important one for tea-growing. The
dark green bushes in their perfectly rounded rows give
the countryside an upholstered look.

Passing through these occasional fields of tea turns out to
be the right approach to take to Katsura, since the most
exquisite feature of the villa is two tea houses set out on
the pond at a distance from the *shoin*. The tea houses
and various aspects of the grounds evoke other mod-
ernist associations in addition to the Miesian ones Ishimo-
to detected. As one walks around the grounds, one
begins to understand how Katsura both inspired and
instructed a photographer. Consider, for example, the
winter tea house called the Shokin-tei, or Pine Zithern
Pavilion, which was constructed in the early 1600s in
what is known as "the eight-window style." The term
makes clear that tea houses were built to be viewpoints
from which to contemplate the pond and garden, and
the prospect through the windows has been thought out
the way a meticulously composed photograph is.

The day Ishimoto returned to Katsura, the earthen-
colored walls with which a window in the Shokin-tei
surrounded the view affected how the scene outside
looked much as the viewfinder on a camera would. The
dimness of the tea-house interior intensified the contrast
outside between pink azaleas and drizzle-slicked leaves
under an oppressive sky. Ishimoto's photographs of Kat-
sura are in an "eight-window style" of their own. When

one walks from the Shokin-tei down to the water's edge, one notices another startlingly modern touch in the way a landing there is purposely misaligned with one on the opposite bank of the pond. Elsewhere, a little hump-backed bridge is also offset from the line of approach down a long, straight path.

These small gestures are disconcerting in a classical space, but that was the intention of Katsura's master designer, Kobori Enshu. To set a scene so that something is askew, out of place, not quite right, is the sort of thing modern pictures do in order to get our attention in a visually overstimulating environment. Besides, we think of our world as one full of discontinuities and unexpected changes. Street photography Ishimoto had been doing in Chicago and Tokyo before he came to Katsura is full of these modern kinks. But to find comparable moments in a 300-year-old garden—that was something else!

These photographic effects are enhanced at Katsura by "jumping stones," which are stepping stones that are irregularly set to force one to look down at the path until arriving at a prospect (see fig. 3).[9] Thus does one have the scene thrown whole and complete before his eyes the way it is in a photograph. At these moments and a dozen others, it is possible to see why Ishimoto was eager to photograph Katsura from a new point of view. Circling the grounds again on his most recent return, the photographer himself had his old passion for the subject rekindled at times.

Yet in the end, the trip was for him a melancholy one. The day after the visit to Katsura, Ishimoto went to an historic temple in Kyoto where noisy tourists were crowding around a monk selling religious articles in the souvenir shop. In the rock garden nearby was a sign reading in Japanese and English, "Be Quiet." Because of tourism, Katsura, too, is now somewhat desecrated by this atmosphere that saddens Ishimoto. Ironically, the runaway populism to which he objects is the ultimate, unintended consequence of the effort, represented by his own book on Katsura, to make national shrines more approachable to the Japanese public.

* * *

The kind of reorientation to one's own culture attempted in Ishimoto's photographs of Katsura is precisely what László Moholy-Nagy demanded of "contemporary man" in the opening paragraphs of his posthumously published book *Vision in Motion*. Moholy spoke of how "old ideologies" and "obsolete practices" had prevented humankind from achieving the new "cultural reality" that the twentieth century required: "The result has been and still is misery and conflict, brutality and anguish, unemployment and war. Emotionally most people live within the old dimension of anachronistic fixations, tribal prejudices. . . . We have to free the elements of existence from historic accretions, from the turgid symbolism of past association, so that their function and effectiveness will be unimpaired."[10] Moholy was thinking of Europe since the industrial revolution; yet his words describe perfectly the situation that Ishimoto's pictures of Katsura addressed in postwar Japan.

Moholy had founded the Institute of Design, originally

known as the New Bauhaus, when he fled from Europe to Chicago in 1937. Ishimoto discovered *Vision in Motion* when he first came to Chicago at the war's end, before he had even entered the I. D. It is fitting that a passage so loaded with meaning for Ishimoto's Katsura project should have come right at the beginning of Moholy's text, for the origins of Ishimoto's entire life's work lay in his beginnings in Chicago, in the first few years he spent there as a student. This Ishimoto himself readily admits, and it is the reason he has made a donation of his work to the Art Institute. Grateful though he is to be celebrated in Japan, he wants as much to be remembered in America and, particularly, in Chicago. The Japanese nation has made him a "Person of Cultural Merit," a high honor that entails a fellowship for life. Yet only by reviewing the early lessons Ishimoto absorbed at the I. D. can one understand how he became an august personage in his own country.

The journey that Ishimoto was on when he came to Chicago was of a type more common to Western culture than to Japanese: the young man's search to find himself. Born in San Francisco in 1921 during a decade when his father was working for a salt company there, Ishimoto had been taken to Japan when he was three and didn't return to the United States until 1939, when his family sent him back to California to study agriculture. But the education he got in American farming methods was not the one his father had planned. It was as forced labor in a crop production program when, during World War II, he was put into the Amachi Internment Camp in Colorado for four years. This experience turned his search for himself into a process closer to wandering in the wilderness. While he seems surprisingly unembittered by his intern-

ment,[11] it must have soured him on a career in agriculture. Upon his release at the war's end, he transferred to the architecture program at Northwestern University.

As documentation he did at Amachi demonstrates (see fig. 4), Ishimoto was already taking photographs before he came to Chicago. After arriving in the city, he joined the Fort Dearborn Camera Club, an amateur organization at which he could use the darkroom and show his early experiments. But the pictorialism still in vogue at such clubs was abandoned as soon as he began educating himself with books like Gyorgy Kepes's *The Language of Vision* and Moholy-Nagy's *Vision in Motion.* The latter was the key text for Ishimoto. It is a sign of the truly universal nature of Moholy's concept that much of what he wrote could seem relevant, and even sympathetic, to a quiet, serious young Japanese who was searching for the way.

Look at the following poem that is, like the commentary on outworn ideologies quoted above, found early in Moholy's book:

> The sea rolls against a sandy beach; the waves subtly corrugate the sand.
> A painted wall cracks; the surface becomes a web of fine lines.
> A car moves in the snow; the tires leave deep tracks.
> Rope falls; it lies in smooth curves on the ground.
> A board is cut; it shows the marks of the saw.[12]

The power of close looking illustrated by these lines had a particular resonance for Ishimoto. The lines echo many of the haiku in one of his favorite books, *Narrow Road to a Far Province,* by the seventeenth-century poet Bashō. This volume was what a young Japanese would bring

along as a guidebook, a vade mecum, on a journey undertaken in search of himself. One haiku reads,

People of this world
Notice not its modest blooms –
The chestnut by the eave.[13]

Ishimoto was someone who *did* notice these things, and Moholy's *Vision in Motion* encouraged him to feel that his preoccupation with the everyday detail in life—the shape the rope assumes when it drops to the ground, the way paint weathers on the wall, the nearness of a chestnut flower to the edge of a roof—was not just idle curiosity. Another haiku from Bashō's narrative goes,

In this hush profound,
Into the very rock it seeps –
The cicada sound.[14]

This is very beautiful, very keenly observed. But what applicability might the refinements of traditional Japanese culture have in a modern, urban world? This question was the inextricable other side of the one about how Japanese history, as embodied in a shrine like Katsura, might yield to modern reinterpretation. In Moholy, Ishimoto found a kindred spirit who might have answers to such questions.

On the same page of Moholy's book where the verses appear, photographs taken by his students illustrate the tire tracks in snow and the pattern of cracks in paint (fig. 5). In his chapter on "Photography" later in the book, referring back to another of the verbal images in the poem, Moholy gave as an example of appropriate subject matter for a photograph "the chiseled delicacy of an ordinary sawn block of wood."[15] Not surprisingly, a couple of the possibilities that the poem describes turn up in Ishimoto's photography. The patterns left by waves on a beach are the subject of a double-page spread at the beginning of his first book, *Someday, Somewhere,* published in Japan in 1958 (fig. 6), and in the aftermath of a winter storm, cars in snow were to provide him with one of his most often reproduced series (see pp. 66-67).[16]

In the photograph of a beach, the pattern in the sand replicates the crashing waves beyond. The sand becomes a still picture of the moving water in the background. This juxtaposition of corresponding elements within the frame is a compositional device found in much street photography that Ishimoto did after he entered the I. D. in 1948. The introduction to *Vision in Motion* ends with a series of definitions of the phrase Moholy used as his title, one of them being "seeing while moving."[17] Nothing could describe street photography more succinctly. Street photography is the ability to anticipate the balanced composition, the arrival of like forms in the frame, while you the photographer are on the move and the subject itself is in motion as well. This is one of the things that Ishimoto's four years at the I. D. taught him how to do.

Yet this isn't the use of the medium that Moholy's book emphasizes. The exercises that *Vision in Motion* outlines for his students run more to technical experiments done in the studio or the darkroom, manipulations of the medium like photograms, double exposures, solarization, reticulated negatives, etc. Moholy's aim was to integrate photography into a curriculum for training designers, not to study the medium for its own sake. Consequently, while *Vision in Motion* was a provocative, in some ways inspiring, book for a young photographer of Ishimoto's inclinations, it was not, by itself, very instructive. Ishimoto needed somebody who could speak more directly to the

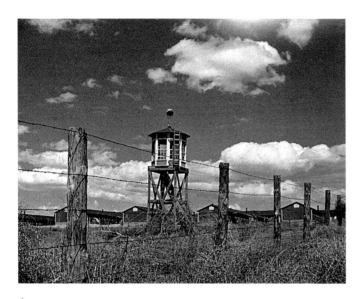

4

5

Fig. 4 Amachi Internment Camp, Colorado, 1942

Fig. 5. From László Moholy-Nagy, *Vision in Motion* (1947), p. 36

Fig. 6. From *Someday, Somewhere* (1958)

6

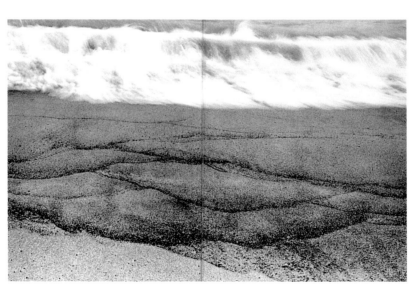

passion he was developing for photography per se.

The connection between Moholy's ideas and the type of photographic practice at which Ishimoto was to excel was made for him by the photography teacher Moholy had hired shortly before he died, Harry Callahan. Basically self-taught as a photographer, Callahan was interested less in the theoretical implications that absorbed Moholy than he was in the medium's practical applications. Callahan moved the assignments given to I. D. students out of the studio and darkroom and into the real world of the city where the notion of "seeing while moving" could take on a new meaning. It was Moholy as interpreted and mediated through Callahan that was the essence of Ishimoto's education at the Institute of Design.[18]

Callahan offered Ishimoto something far more important than lessons in technique, however. He approached his work in the classroom with a modesty that made him one of the great photography teachers of all time. Ishimoto recalls that Callahan never used his own work as a model for his students to imitate, nor did he even show his work to them. The first time Ishimoto saw one of Callahan's own pictures, it was by accident when he happened upon a print that his teacher had left in the washer in the I. D. darkroom. Callahan's students didn't actually get a look at his work until he exhibited it along with theirs in the annual benefit auction held at the end of each school year. In fact, many of Callahan's pictures in this period were made in response to his own assignments at the same time that the students were doing them.[19]

Callahan's lack of egotism served well one of the ideals on which the I. D., like the Bauhaus before it, had been founded. The school's aspiration was to function as a collective where a common vision was realized through a shared discipline. This goal was derived from that aspect of modernism that rejected the old romantic figure of the artist as a unique individual genius. Especially as its values were represented by Callahan, the I. D. was therefore a very congenial environment in which a young Japanese, coming as he did from a society that put emphasis on collaborative achievement over self-assertion, could flourish. Ishimoto produced some of his best work ever within the structure that Callahan's assignments provided.

* * *

In 1969, seventeen years after completing his course of study at the I. D., Ishimoto published a book in Japan entitled *Chicago, Chicago,* and as its last picture he chose an image of some sheets of newspaper blowing through Grant Park on a summer day (see p. 1). It is an image of the hot air of the American press (nothing could typify that better than the *Chicago Tribune*), and of the Windy City, as Chicago is called. The photograph's allusion to Chicago's nickname makes it a fitting end to the book, though at first glance the image seems completely unassuming. Like the humble bridge at an odd angle at the end of Katsura's grand *allée,* this picture takes you by surprise as a conclusion to the book. In fact, Ishimoto pursued those sheets of newspaper for over an hour. There is nothing casual about the photograph. It instills into the book's ending a "hush profound" like that in which the sound of the cicada seeps into the rock in Bashō's haiku.

The opposite of vision in motion is patience—watchful waiting—and this, too, is a talent that street photography requires. Sometimes both virtues have to be exercised at once, as when Ishimoto was stalking that newspaper being whipped about by the wind. At other times, patience means keeping very still in order not to disturb a situation that is evolving. An example of this is Ishimoto's photograph of a black nanny tending a white child in a baby buggy (see p. 94). He delayed making his exposure until the woman turned the pages of the magazine she was reading to one whose graphics were large enough to register in his photograph, to make his image complete in every detail. Willing to wait an hour for the right instant to arrive for a picture, he was also willing to wait a year with another subject because the seasonal course of the sun had moved a shadow beyond where he wanted it to fall. Having spotted some crucifixes in a window whose mullions cast a cross-shaped shadow, he returned a week later with a 4 × 5 in. camera. But he found that the light had shifted. Dissatisfied with the possibilities under these changed conditions, he waited until the same season a year later to get the picture (fig. 7).

Episodes like these betray a single-minded tenacity also evident in Ishimoto's career as a whole. That he should have ended Chicago, Chicago with an image he had chased relentlessly was appropriate because the book was itself the outcome of a determined pursuit of the city it depicts. From 1959 to 1961, Ishimoto was back in Chicago on a fellowship from the Minolta Corporation. The life that he and his wife were able to live on this grant was very spartan. Joe Sterling, who was a student at the I. D. when Ishimoto returned to Chicago, remembers that Ishimoto would daily walk over five miles from his North

Side apartment near Belmont Avenue to the I. D. campus on the South Side, taking pictures as he went.[20] Ishimoto's wife, Shigeru, also recalls that the lights had to be turned out throughout their unpartitioned apartment when Ishimoto set up his darkroom in the kitchen each night. After dinner, she would clear away the dishes and then sit in the dark while her husband printed his photographs.[21]

The dedication with which Ishimoto approached the city had a monastic quality about it. Chicago became like a pilgrimage site for him, taking on, through his devotion to it, a sacred character not so different from that of Ise. Just as he had to apply three times to photograph Ise—in 1953, 1973, and 1993—before permission was granted, so did periodic returns that he made to Chicago represent a constancy of purpose. Having been a student in Chicago from 1948 through 1952, he was back ten years later taking pictures on the Minolta fellowship and having a one-man exhibition at the Art Institute. The publication of Chicago, Chicago in 1969 was still another way in which he revisited the city in order that his vision of it might be realized.

Chicago, Chicago gives the impression that every photograph in it has been chosen and placed as thoughtfully as the last one in the book. The book opens with a sequence in which the city is slowly but inexorably destroyed. One building after another dating back to the nineteenth century is demolished. But then a new, modern city begins to emerge from the rubble. Up and up it goes, towering overhead, dwarfing the people in the street. Amid the new buildings, the inhabitants gather in a tiny patch of light within a deep well of shadow as ominous as the initial destruction of the city was bleak. Cast

thus into the shade, the new facades seem to forebode the starting up again of the endless cycle of destruction and development that American capitalism requires to keep going.

Pictures made in this shadow world were singled out by Minor White in a short essay he wrote for a pamphlet that the Art Institute issued at the time of Ishimoto's exhibition. "The pictures grow out of black," he observed. "The light . . . remain[s], in some compelling way, attached to darkness."[22] White noted as well that many of Callahan's students had "learned" such effects "from the atmosphere around them" at the Institute of Design. This is true. Dramatic lighting of this type abounds in a vision of Chicago to which I. D. photographers ranging from Ishimoto in the early fifties to Ken Josephson in the early sixties contributed. The mutual exploration of specific ideas like this makes it appropriate to speak of the work that came out of the I. D. as a Chicago school of photography, rather than just a style.

Nor were I. D. motifs the only part of the "atmosphere" that affected Ishimoto at this point. Robert Frank's book *The Americans* was published in the United States the year Ishimoto returned to Chicago, and Art Institute curator Hugh Edwards, who offered Ishimoto his show, gave the photographs from Frank's book one of their first American exhibitions the year Ishimoto left. The intricacy of Ishimoto's sequences in *Chicago, Chicago* make them seem indebted to Frank's book, and Ishimoto's sensitivity to racism is another point of similarity between the two men, both of them outsiders looking at America from the perspective of another culture. Yet here as with themes held in common by all I. D. photographers of the period,

Ishimoto turned any ideas he may have gotten from other photographers into his own.

Precisely because he saw an aesthetic idea as a joint venture, like all of culture, he was able to use anything that might make an impression on him with a special freedom—without the guiltiness or insecurity that a more self-conscious talent might have felt. Not even Alfred Stieglitz intimidated him when, several decades later, Ishimoto decided to do studies of clouds like Stieglitz's famous "Equivalents." After returning to Japan in 1962, Ishimoto became a teacher at the Tokyo College of Photography and the Kuwasawa Design School, and one of his students from those days has said that an important lesson he learned from Ishimoto was that "similarity and imitation are the bases of culture."[23] Besides, when Ishimoto was struck by the work of someone else, it was because he had already developed on his own a need for what it offered and a context in which to fit it.

Like Frank's *Americans,* Ishimoto's book employs montage to advance its picture sequences. The book is a lyric paper movie. But then, Ishimoto had already made a movie when he was a student—a twenty-minute documentary entitled *Maxwell Street* that he did with classmate Marvin Newman—and particularly rich situations he came upon as a street photographer he sometimes shot as sequences that could almost be run through a Moviola like a silent-film short. A contact sheet of a little girl leaning against the wall of a church is an example. *Chicago, Chicago* calls attention to the cinematic quality of its picture editing with a double-page spread containing two frames from this shot sequence (fig. 8). If Ishimoto was impressed by Frank's book, as almost all street pho-

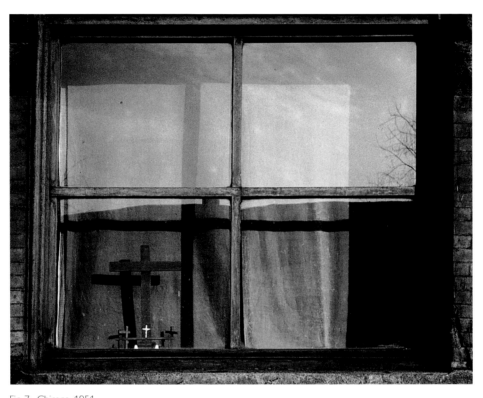

Fig. 7. Chicago, 1951

Fig. 8. From *Chicago, Chicago* (1969), pp. 122-23

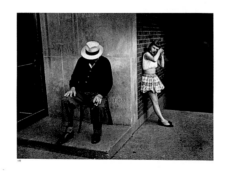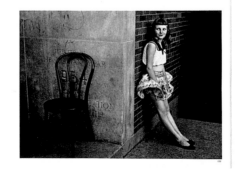

tographers were at the time, in his case it was because he knew what to do with the precedent that *The Americans* offered.

Perhaps because he had been subjected to American racism himself when he was interned in Amachi, Ishimoto was able to approach race relations in this country with even greater compassion and understanding than Robert Frank did. He saw the oppression of African Americans as it was written on the face of a black man who, surrounded by whites at a baseball game, sank into the shadows next to a pillar until he almost literally became Ralph Ellison's Invisible Man (see p. 87). But Ishimoto also saw the great spirit of people of color in America, like the saucy little girl brandishing two American flags and looking with glee at an elderly white woman who looks back with a disdain that the child cannot yet grasp (see p. 33). A Callahan assignment to photograph people who knew they were having their picture taken produced some of Ishimoto's best portraits when he went into the black ghetto that did then, and still does, surround the Institute of Design (see p. 90).

Like the victims of American racism, the American Lolita was a figure Ishimoto was particularly sensitive to. That little girl leaning on the church wall with her skirt blowing up is an example, as is another child the photographer caught as she wrapped herself in a blanket at the beach with a disconcertingly erotic grace (see p. 83). Again, Ishimoto's awareness of such American foibles was no doubt aided by his being an outsider by birth. The man who gave Lolita her name, Vladimir Nabokov, came from a culture as remote from America's as Ishimoto's was.

The most poignant glimpse of the American Lolita that Ishimoto ever got was a photograph that seemed to carry a curse for being too provocative, as if it had to be destroyed like a graven image to placate a Puritan God. The photograph is Ishimoto's best known from the 1950s because it is one that Edward Steichen featured prominently in *The Family of Man* (fig. 9). Like the girl wrapping herself in a blanket, this girl tied to a tree during a game of cowboys and Indians is seen in a moment of classical contortion. She has assumed a posture that makes her look eternal, like a saint in the throes of her martyrdom in a Renaissance painting. Otherwise, the edge of sexuality, of wantonness and bondage, might have put the image beyond the pale of what can be looked at comfortably.

As it was, the picture seemed destined for oblivion. When *U. S. Camera Annual* published the photograph in 1953, the editors attributed it to someone else. Then, after a large-scale blow-up had been made for *The Family of Man,* Edward Steichen lost the negative. Ishimoto had foolishly loaned the original to him without making a copy negative or even being sure to have a good print of his own. For over forty years he has had only copy prints of poor quality, until two vintage prints unexpectedly resurfaced in the late 1990s. One of them, battered and marked up for reproduction, is the print that Ishimoto had sent to *U. S. Camera.*

Peculiarly American themes like racism and Lolita are not what give Ishimoto's Chicago work its distinction, though. It is not the aspects of American life covered in his street photography that make the work done here since the 1950s compelling. It is the subtlety with which these sub-

Fig. 9. Chicago, 1948/50

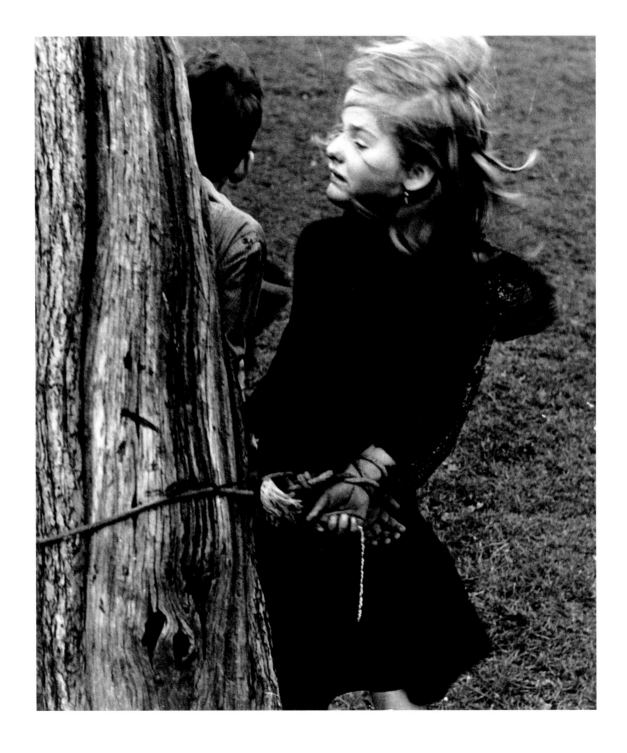

jects are observed. The delicacy with which a man's hand touches the chevron on a policeman's coat as the man works his way through a crowd (see p. 86) tells us more than a hundred newspaper exposés on corruption about where power lies in an American city and how it is honored. (The occasion was in fact a mobster's funeral.) Amidst the tangle of legs in front of the hot-dog stand at North Avenue Beach is a boy, a little toughie with a pot belly and a scowl on his face; his attitude and expression foretell, or perhaps forebode, the man he will become (see p. 81). Pitched against a couple chatting as they walk along a Chicago street, the wistfulness of a woman seated in a window above a bar and grill gives image to the loneliness of big city life (fig. 10).

The woman and the couple are as oblivious of each other as the chestnut bloom is to the eave of the roof in Bashō's haiku. Yet like the flower when seen against the eave, the woman alone is made vivid by the presence below of two people together. If not for them, we might have missed her altogether, because the picture is so still and eventless. The picture is one of strangers, people who don't know either the photographer, us, or each other, and it has been taken from across the street in a vaguely seedy part of town where everybody minds their own business. Ishimoto's distance from his subjects imbues his photograph with the loneliness we sense in it.

Still, there is something intimate about the scene. Though on public view, the woman at her window is caught in a moment of dreaminess that is private. The photograph invites us to enter the dark recesses of her apartment, her situation, even her emotions. The image's ability to do all this is a question of scale and of placement in the frame. The effect is the same as in Ishimoto's favorite rock gardens in Kyoto, where the size and position of a single stone and the proximity to it of a bit of moss can fill an otherwise empty space.

* * *

While Ishimoto has taught photography in Japan, he never studied it there as he did in America. If there was any Japanese master under whom he might have studied as profitably as he did under Callahan, it was not a photographer: it was the poet Bashō. Like the education Ishimoto received at the I.D., the haiku was a form that stressed collaboration among poets, and Bashō apparently had the sort of modest, unassuming methods as a teacher that distinguished Callahan.[24] In an enlightening essay entitled "Bashō on the Art of the Haiku: Impersonality in Poetry," Makoto Ueda stressed that Bashō "never wrote a theory of poetry."[25] Like Callahan, who ultimately rejected Bauhaus dogma about photography, Bashō taught through terse reactions to his disciples' work rather than elaborate instructions.

"Impersonality," as Ueda applied the term to Bashō, is what Callahan's students achieved by submitting to a common discipline out of which came a mutual way of thinking about pictures that was purposely not the creation of any one photographer working alone. "The main task for the Haiku poet," Ueda explained, "is to immerse himself into the heart of an object or an incident . . . and to catch the impersonal mood it shares with the universe."[26] Ishimoto's photographs of a newspaper in the wind, a hand touching a policeman's sleeve, or a woman alone at a window have just this mood of a universal truth impassively illustrated.

Fig. 10. Chicago, 1959/61

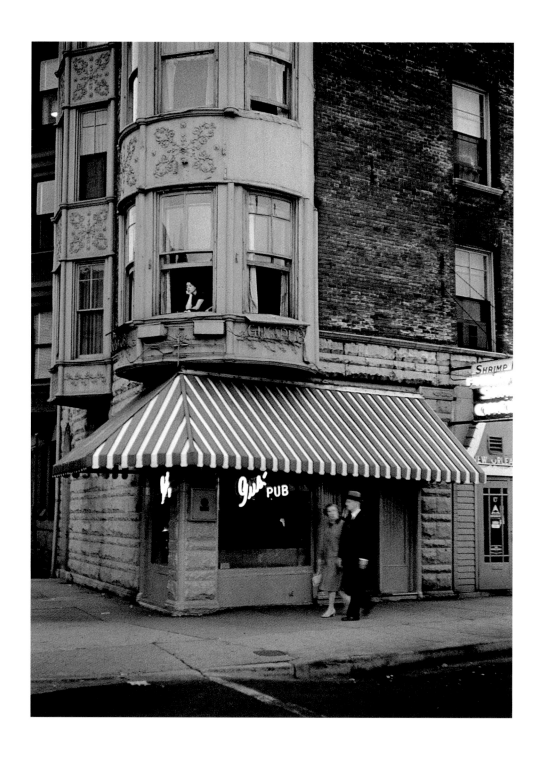

According to Ueda, Bashō felt that the profound perceptions of the poet can be sustained "only for a few moments at most." His revelations are but a "glimpse" into the nature of things. The spontaneity with which the poet must react makes his craft a model for the photographer's. In Bashō's own words, "If you get a flash of insight into an object, . . . let there not be a hair's breadth separating your mind from what you write. . . . [N]ever hesitate at that moment." The instantaneous quality that the composition of the poem must have makes it "like leaping at a formidable enemy, . . . or like biting into a pear."[27] These precepts could be a description of Ishimoto at work.

American and European street photographers have discovered for themselves the relevance to their art of Japanese religious and aesthetic ideas. The most notable example is Henri Cartier-Bresson, who has acknowledged the importance to him of Eugene Herrigel's little book *Zen in the Art of Archery*.[28] But the relationship of Ishimoto's work to Bashō's is more pervasive and entangled. "Simply observe what children do," Bashō says,[29] and Ishimoto does, in some of his most affecting photographs made in either Chicago or Tokyo. Even the principles of cinematic montage apparent in the way certain Ishimoto photographs relate to each other in his frame sequences or in his picture editing of his books seem to have been anticipated by Bashō's concept of "reverberation" between images in his verse.[30]

The intuitive quickness that Bashō brought into Japanese poetry resulted in what Ueda called "lightness," by which he meant "the beauty of naïveté rather than of sophistication; . . . of the shallow rather than of the deep."[31] Ishi-

moto's photographs are like this—playful, even though he is completely serious about the making of them. Ueda could not have put the case for a street photographer like Ishimoto better than when he said of the haiku poet, "He does not flee from the world of ordinary men; he is in the middle of it, understanding and sharing the feelings of ordinary men; he has only to be a bystander, who calmly and smilingly observes them."[32]

Like Katsura, Bashō provided Ishimoto with a way to link Japan and its past to the modern world the photographer had discovered in Chicago. When Ishimoto returned to Tokyo in 1953 and again in 1961, he simply continued there the work he had begun in Chicago. The portrait series he had done of kids in the street, especially in Halloween costumes, was extended to Japanese children in similar get-ups (see p. 118). A double exposure he made of people passing before a dark background on a Tokyo street (see p. 135) also demonstrates how ideas from Chicago were translated into Japanese, since pictures like these were being done in Chicago by Callahan and others from the I. D. In both the early 1950s and the early 1960s, Ishimoto used strategies as a street photographer imported from Chicago to get his bearings at home. He was trying to see where he stood in his own society— where he needed to stand in order to apply the vision he had developed in America.

The direct line that can be drawn from Ishimoto's Chicago days through his return to Tokyo can be extended from the early Tokyo pictures right through the most recent work. Yet after some forty-five years spent almost entirely in Japan, his imagery appears to have become very Japanese in character. Now in his late seventies, he is

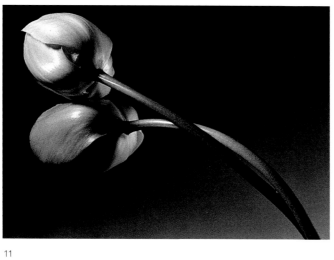

11

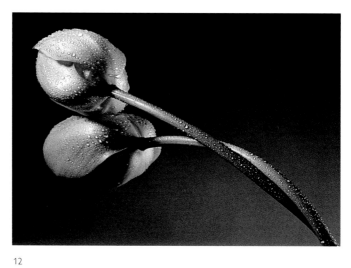

12

13

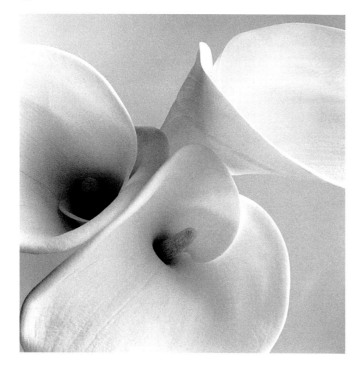

Fig. 11. Tokyo, 1995

Fig. 12. Tokyo, 1995

Fig. 13. Tokyo, 1987

doing work of a meditative kind that we might expect from an artist who is advanced in years. The pictures are of flowers (figs. 11-13) and clouds (see pp. 17 and 137), of fallen leaves (see pp. 133, 141, and 143) and footprints in snow (see pp. 16, 136, and 144), or of the surface of a pond in a park near his home when the water is ruffled by the wind (see p. 142). All these subjects remind us of the way commonplace detail is isolated in much traditional Japanese painting. Both the subject matter of the photographs and Ishimoto's treatment of it are the stuff of which haiku are made. Indeed, the footprints in snow look like the calligraphy on the page where the poem is written (see p. 144).

Shigeru Ishimoto sees these found still lifes as related to the studies Ishimoto made at Ise in 1993 (see p. 117) and another project done at a temple in Kyoto twenty years earlier, the photographing of the Den Shingon-in Ryokai Mandala, an ancient painting on cloth of the iconography of Esoteric Buddhism (see p. 119).[33] Producing books on this sacred object in Kyoto and the shrine at Ise required the artist to humble himself before his subject, to approach it with utter deference. In its own way, each kind of picture—both the meditations on leaves, clouds, or snow and the documentation of a mandala or a shrine—goes to the essence of something Japanese.

Even in his application of a rigorously Japanese attitude toward very Japanese material, however, we can see Ishimoto's photography circling back to its roots in Chicago. The footprints in the snow, the leaf rotting on the asphalt, and the light moving on the water are all of a piece with the wave's corrugation of the sand or the tire marks in snow with which the poem in Moholy's book guided Ishi-

moto to some of his earliest pictures. The recycling of the first ideas into the latest work affirms the pattern of eternal return in Ishimoto's photography. This is equally obvious in the way that Ishimoto has redone a couple of his books, visiting again subjects he has dealt with before, refining his vision of them, rather than going on always to new ones.

His 1969 *Chicago, Chicago* was followed in 1983 by a second book that has the same title but was done with completely different pictures, and in the same year a new book on Katsura came out that complemented that done in 1960. Whereas the first Katsura book was a collaboration with Kenzo Tange from a modernist point of view, the second was done with the post-modernist architect Arata Isozaki. While the earlier pictures suppressed decorative detail in order to emphasize a similarity to Bauhaus design in Katsura, the second book, done in color, singles out decor like the finger plates with which the screens are slid aside on their tracks, the pale gold pattern in the white wall coverings (see p. 111), a famous painting on the door of a compartment in a built-in bookshelf, etc. The new book doesn't repudiate the old one. It simply sees the subject in a different light, the way someone stepping onto the moon-viewing platform at Katsura might contemplate the moon in different phases on different nights.

Still another ritual through which Ishimoto has revisited his life's work is the re-printing of all his negatives on Oriental paper since the early 1980s. He has always been a dedicated and meticulous printer. The greatest benefit he got from belonging to the Fort Dearborn Camera Club in his early days in Chicago was that for the price of the

membership he could use the chemicals and darkroom, which was always deserted on weekdays. A few of his early still lifes were even done with gold toning typical of the pictorialist tastes in prints the club represented. But the I. D. inculcated him with the aesthetic of straight black and white, or gelatin silver, printing. One can see from prints made even in his student days his attention to the craft of printing. Close examination shows that his prints required almost no spotting—that is, filling in by hand white holidays on the print caused by dust on the negative—because his friend Marvin Newman, who was working in the *Time – Life* lab, taught him an especially effective procedure for getting his negatives dust-free before printing them.

In Chicago, Ishimoto printed on Dupont paper, and when he returned to Tokyo he used an equivalent manufactured by Mitsubishi. But these papers were either glossy or semi-gloss, and they never satisfied him. In 1962, shortly after his return to Tokyo, a new Mitsubishi paper became available that pleased him more, so he began reprinting his earlier work. But then twenty years later when Oriental, which is a matte paper, came on the market, he switched to that and began again to re-print his entire archive. The reason he likes this material can be seen in his rendering of the footprints in snow. Black and white photographs of a stark white subject tend to lose all detail; yet in Ishimoto's pictures you can see even the porous quality of the snow's surface. This degree of resolution was achieved by shooting at exposure times as much as a couple of minutes with a film that has a very fine grain, and then carefully bringing out the detail by taking advantage of the tonal range that the Oriental paper has.

Prints like these are examples of that deference to the subject matter spoken of earlier; the desire to be true to what he photographs that Shigeru Ishimoto sees as reaching in his late work from profound subjects like Ise all the way down to seemingly insignificant ones, like a decaying leaf or footprint in the snow. At the same time, though, there are photographs of flowers or clouds where Ishimoto has gently but irresistibly pushed the limits of his materials and his medium until the description breaks down. As it gradually shifts in tone, the speckled grayness of the surface of a cloud becomes so insubstantial that the grain inherent in the photographic materials shows right through. It is as though the dot pattern created by the grain of the film were an image of the drops of water suspended in the cloud. In like manner, the whiteness of a calla lily as it curls in on itself brightens by degrees until the whiteness of the photographic paper is what we're looking at (fig. 13).

No matter how late he may have been out, most nights Ishimoto goes into his darkroom for a couple of hours before retiring. There he not only prints his current work, but practices the discipline of renewal inherent in making new prints from old negatives. The gelatin silver prints he makes are all 11 x 14 in.—small by contemporary standards—because that is the largest he can do in the little darkroom into which he has converted a storage closet of his Tokyo apartment. The darkroom is Ishimoto's "Ten Foot Square Hut." This is the title of a thirteenth-century Japanese tale that he recommends to admirers of his work, telling them that just the first page or two will lead to a better understanding of his art. The importance to Ishimoto of Moholy's *Vision in Motion* can be gathered from its first few pages, too. Like Moholy's book, "The Ten

Foot Square Hut" is a sourcebook for the photographer, a text in whose very beginnings lie the origins of his own work.

Those first pages of the tale, called in Japanese "The Hōjōki," introduce us to a man who has witnessed all the events both large and small that make up the life of the capital. He has seen the city destroyed and rebuilt and destroyed again—like Chicago in Ishimoto's book—by everything from earthquake and fires to political upheavals. Having understood the way of the world in all its transitoriness, the narrator withdraws to the seclusion of a tiny hut from which he can see the truths he has learned reflected in the natural world. In society as he knew it, "Every one felt as unsettled as drifting clouds."[34] The mood evoked by the opening pages is very much that of the evanescence found in Ishimoto's images of clouds, decaying leaves, footprints in melting snow, and shifting patterns on the surface of a pond. "Dead in the morning and born at night," the first page tells us, "so man goes on for ever, unenduring as the foam on water."[35] Like this world, Ishimoto's is born at night in his darkroom and saved from ultimate dissolution by a constant cycle of renewal.

The narrator of the Hōjōki may well have been a man of affairs before his withdrawal to his hut.[36] The street photographer is a comparable figure, for his "vision in motion" involves him in the life of the city even as he records it. Then, just as the teller of the tale later turns to meditations on nature that are more oblique and symbolic, so too has Ishimoto.

The Ten Foot Square Hut has resonances going back in Ishimoto's career all the way to the Fort Dearborn Camera Club, where he printed his earliest negatives in solitude during the work week when the club was deserted. It is the tiny apartment in Chicago during the period 1959–61 that served as both living quarters for the Ishimotos and, every night, his darkroom. It is the apartment where he now lives, in whose darkroom he has been reprinting his life's work. The Ten Foot Square Hut is also the tea houses that border the pond at Katsura. When these structures appeared in the seventeenth century, they were, it seems, a realization of a myth to which the thirteenth-century Hōjōki gave rise.[37] The tea houses were built as sanctuaries and vantage points from which to view the world in a garden around them. They are the prototypes of all the other ten-foot-square huts in which Ishimoto has dwelled. It is only right that this essay should end by recalling the trip made to Katsura at the beginning, for the entire journey that Ishimoto's career represents is one of endless return to his origins.

NOTES

1. This trip was the result of a commission from a publisher for the book *Islam: Space and Design* (Tokyo: Shinshindo, 1980).

2. Only during reconstructions that occur regularly every twenty years could Ise be photographed. In both 1953 and 1973, Ishimoto was refused permission to enter the precincts of the shrine with his camera, but in 1993 (the last opportunity he felt he would have, since he was then seventy-two years old) he was at last granted permission. See Yasuhiro Ishimoto, Arata Isozaki, and Eizo Inagaki, *Ise Shrine* (Tokyo: Iwanami Shoten, 1995).

3. This conversation with the photographer took place during a ten-day visit the author made to him in Tokyo in April 1998. This was also the occasion on which the photographer returned to Katsura. Background information for this essay was developed during this visit and others that the author had with the photographer in Tokyo in February 1996, in New York in April 1997, and in Chicago in September 1996, August 1997, and October 1998.

4. Herbert Bayer, Walter Gropius, and Ise Gropius, eds., *Bauhaus, 1919–1928* (New York: The Museum of Modern Art, 1938).

5. A book that came out the year after Ishimoto took his pictures—Norman F. Carver, Jr., *Form and Space of Japanese Architecture* (Tokyo: Shokokusha, 1955)—reproduced photographs of Katsura by its author that were often similar in intent.

6. As William Chapman wrote in *Inventing Japan: The Making of a Post-War Civilization* (New York: Prentice Hall Press, 1990), "Japan emerged from the Occupation in 1952 a changed nation. A great deal of the prewar Meiji system had been done away with and could never be revived. . . . In fact, almost all of the country's political and economic relationships were changed and even some of the social habits and customs as well" (p. 27). Chapman's book deals primarily with politics and economics, but in an introductory essay for *The Confusion Era: Art and Culture of Japan during the Allied Occupation, 1945–1952* (Washington, D. C.: Smithsonian Institution, 1997), the distinguished scholar of Japanese culture Donald Richie put the matter of American influence more bluntly when he said, "America's urge to educate . . . found ready fulfillment in this beaten archipelago. Japan's citizens were

willing pupils who had backed the wrong model and were now eager to try out the new" (p. 11).

Japan had opened itself to Western influence in the nineteenth century during the Meiji Restoration of which Chapman spoke, when a Diet had been established that provided the rudiments of parliamentary government. But in the early twentieth century, militarists nostalgic for the Japan of the shogunates before the Meiji period had come to power. With the defeat of these elements at the end of World War II, the nation's history came full cycle again as outside influences reasserted themselves. According to Mikiso Hane's book *Modern Japan: A Historical Survey,* 2nd ed. (Boulder, Colo.: Westview Press, 1992), "The impact of America on postwar Japan . . . has rivaled, if not actually surpassed, the influence that the West had on Meiji Japan" (p. 369). See also Edwin O. Reischauer, *The Japanese* (Cambridge, Mass.: Belknap Press, 1977).

7. Yasuhiro Ishimoto, Kenzo Tange, and Walter Gropius, *Katsura: Tradition and Creation in Japanese Architecture* (New Haven: Yale University Press, 1960), pp. 34–36.

8. Ikko Tanaka, "Yasuhiro Ishimoto," in Yusaku Kamekura, ed., *Creation: International Graphic Design, Art and Illustration,* no. 15 (Tokyo: Recruit Co., 1992), p. 42.

9. See Ishimoto, Tange, and Gropius (note 7), p. 42, and June Kinoshita and Nicholas Palevsky, *Gateway to Japan* (Tokyo: Kodansha International, 1990), p. 364.

10. L. Moholy-Nagy, *Vision in Motion* (Chicago: Paul Theobald and Company, 1961), p. 10.

11. While at Amachi, Ishimoto was sent to work for a period on a farm in Oregon, but he plays down any hardship resulting from the experience. He claims that when he and his fellow internees hunted at night for pheasant, flushing them from the underbrush with flashlights and killing them with a shovel, the motive was sport rather than hunger.

12. Moholy-Nagy (note 10), p. 36.

13. Dorothy Britton, trans., *A Haiku Journey: Bashō's Narrow Road to a Far Province* (Tokyo: Kodansha International, 1974), p. 42.

14. Ibid., p. 62.

15. Moholy-Nagy (note 10), p. 178.

16. In Japan this series became an icon of modern photography that has been memorialized, most recently, on a phone card advertising the "'97 Fujifilm Photo Contest."

17. Moholy-Nagy (note 10), p. 12.

18. For a good summary of the differing influences of Moholy, Callahan, and other teachers on the I. D. photography curriculum, see Andy Grundberg, "Chicago, Moholy and After," *Art in America* (Sept./ Oct. 1976), pp. 34–39.

19. One of Callahan's other students, Art Sinsabaugh, reported that Callahan "would assign a problem . . . and at the end of the class wander off and try it himself." Quoted in Charles Traub, ed., *The New Vision: Forty Years of Photography at the Institute of Design* (Millerton, N.Y.: Aperture, 1982), p. 43. Although I have found no direct quotations from Callahan himself on this subject, two other people who have worked closely with him concur about the importance of his assignments to his own work. Sarah Greenough quoted Sinsabaugh's remark approvingly in the essay on Callahan in her exhibition catalogue *Harry Callahan* (Washington, D. C.: National Gallery of Art, 1996), p. 43; and Callahan's dealer, Peter MacGill, said he has the impression that some of Callahan's best work resulted from trying his hand at the assignments given his students (Peter MacGill, conversation with the author, New York, May 1998).

20. Conversation with Joseph Sterling, July 1996.

21. "Interview with Shigeru Ishimoto" in *Yasuhiro Ishimoto: Chicago and Tokyo* (Tokyo: Tokyo Metropolitan Museum of Photography, 1998), p. 177.

22. Minor White, "Photographs by Yasuhiro Ishimoto" ([Chicago:] The Art Institute of Chicago Gallery of Photography, October 21–December 4, 1960), not paginated.

23. "Interview with Tadasuke Akiyama" in *Yasuhiro Ishimoto: Chicago and Tokyo* (note 21), p. 181.

24. The traditional form of the haiku before Bashō had been as a kind of postulation and response in which one poet would write a seventeen-syllable line and another would give a fourteen-syllable response. For more on the history of the haiku and Bashō's historic role in fixing the form and elevating it to a fine art, see Makoto Ueda, trans., *Bashō and His Interpreters: Selected Hokku with Commentary* (Stanford: Stanford University Press, 1992).

25. Makoto Ueda, "Bashō on the Art of the Haiku: Impersonality in Poetry" in Nancy G. Hume, ed., *Japanese Aesthetics and Culture: A Reader* (Albany: State University of New York Press, 1995), p. 152.

26. Ibid., p. 160.

27. Ibid., p. 162.

28. See Colin Westerbeck and Joel Meyerowitz, *Bystander: A History of Street Photography* (Boston: Little, Brown and Company, 1994), pp. 165–66.

29. Ueda (note 25), p. 162.

30. Ibid., p. 164.

31. Ibid., p. 169.

32. Ibid., p. 167.

33. "Interview with Shigeru Ishimoto" in *Yasuhiro Ishimoto: Chicago and Tokyo* (note 21), p. 177.

34. A. L. Sadler, trans., *The Ten Foot Square Hut and Tales of the Heike* (Tokyo: Charles E. Tuttle Company, 1972), p. 5.

35. Ibid., p.1.

36. Ibid., p. i. The capital depicted in this tale is not Tokyo, but the earlier one of Kyoto.

37. In the introduction to his translation of "The Hōjōki," A. L. Sadler discusses the rise of "Cha-no-yu or Teaism, which enables even busy people to become temporary hermits in the Tearoom, to be in the world though not of it, like the 'moon in the market-place.'" The size of the tea room is traditionally fixed, he explains, at four and a half mats—the same size as the hut in the tale. Ibid., p. iii.

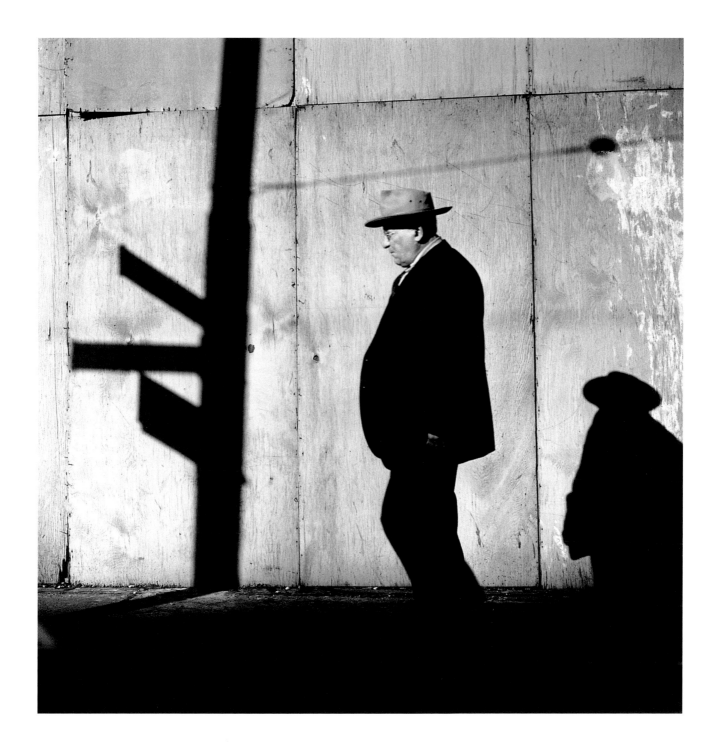

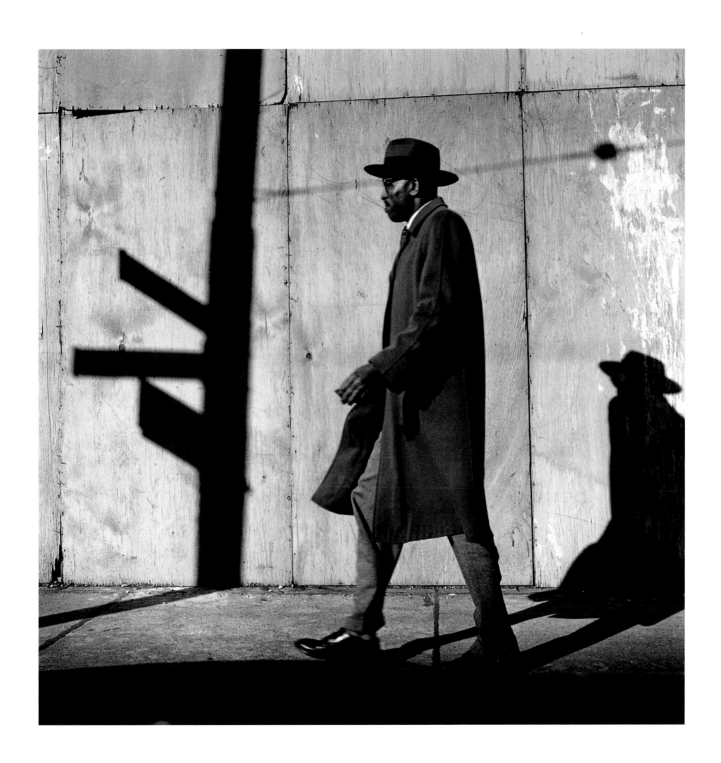

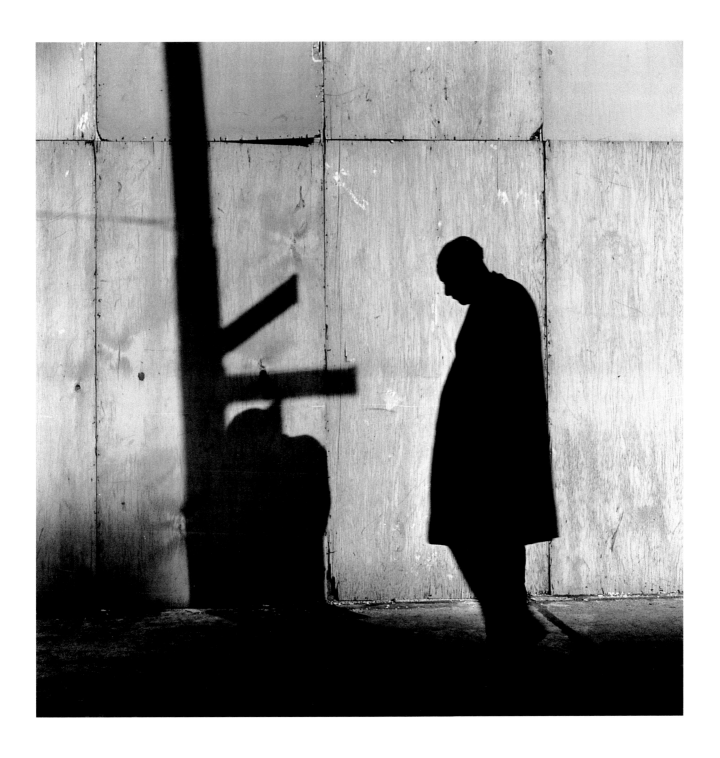

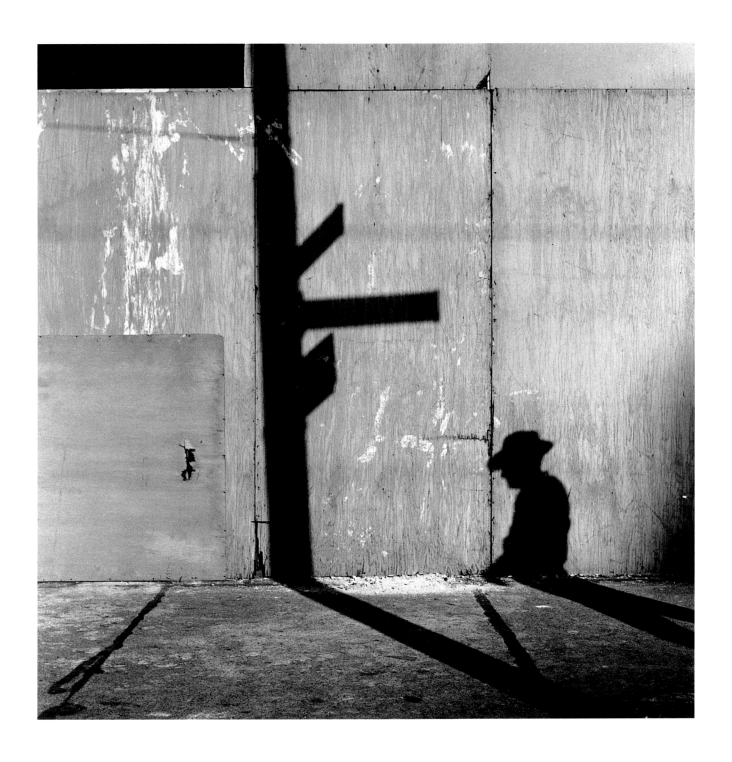

Chicago, 1951

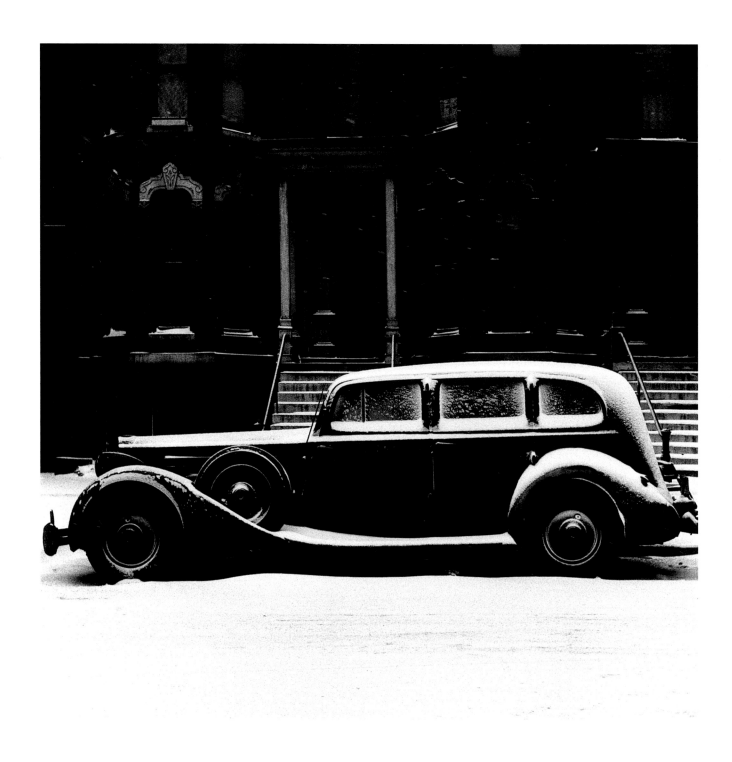

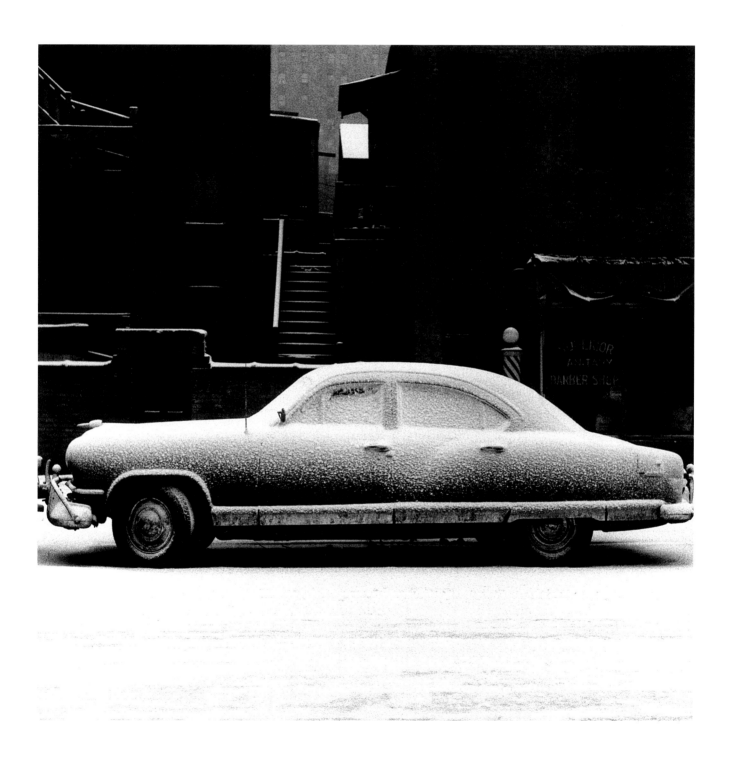

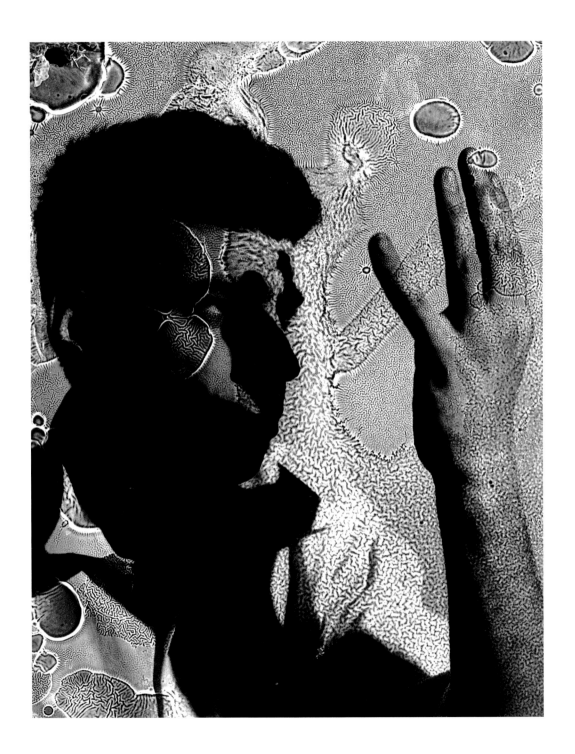

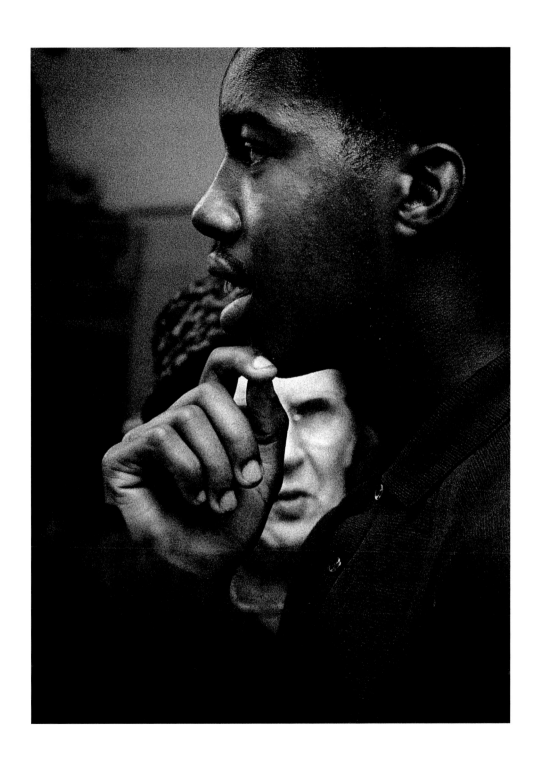

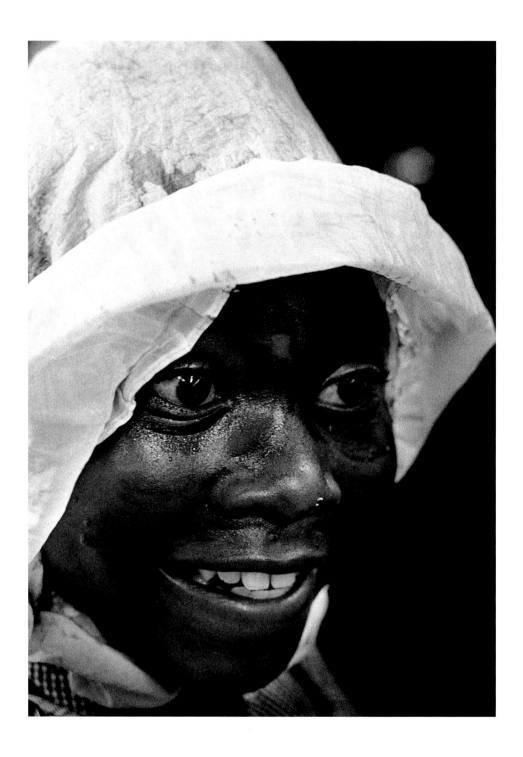

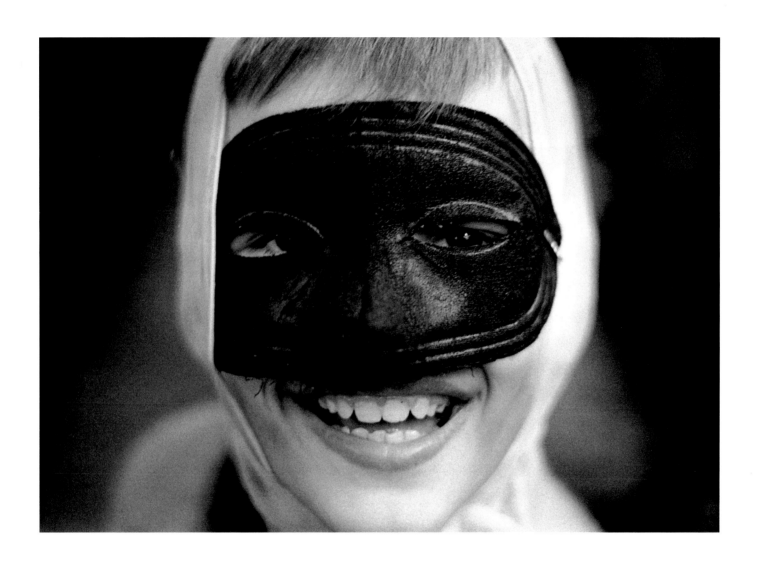

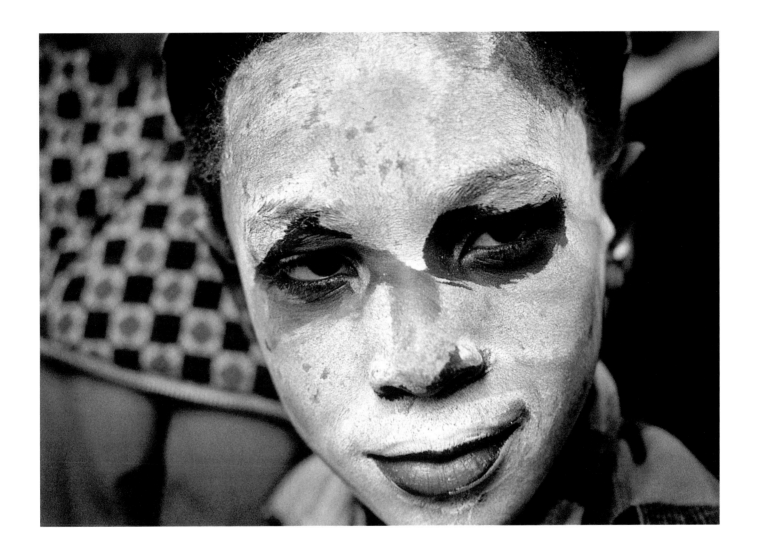

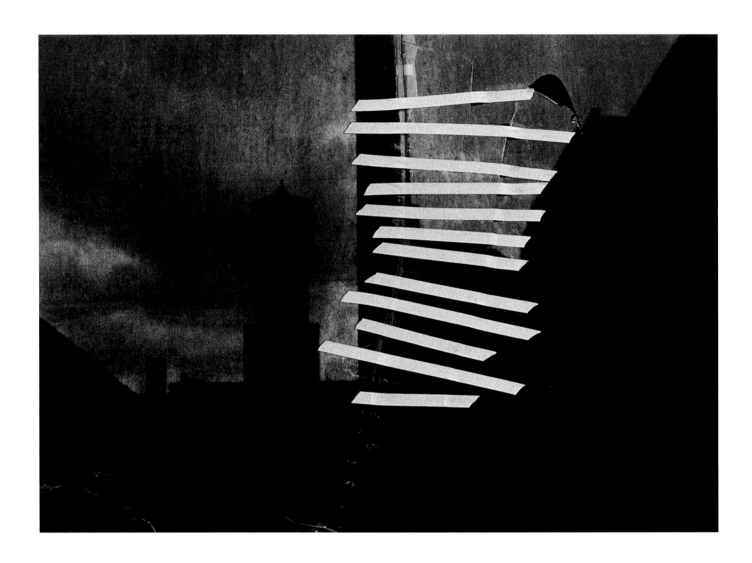

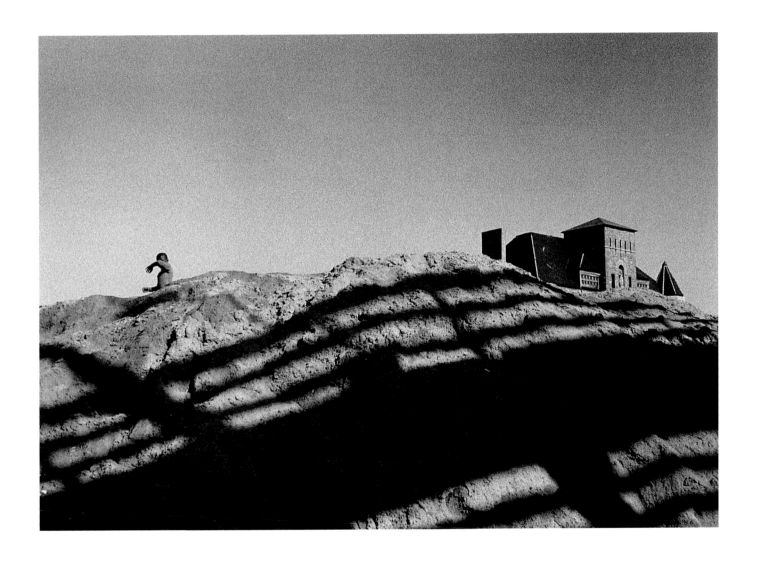

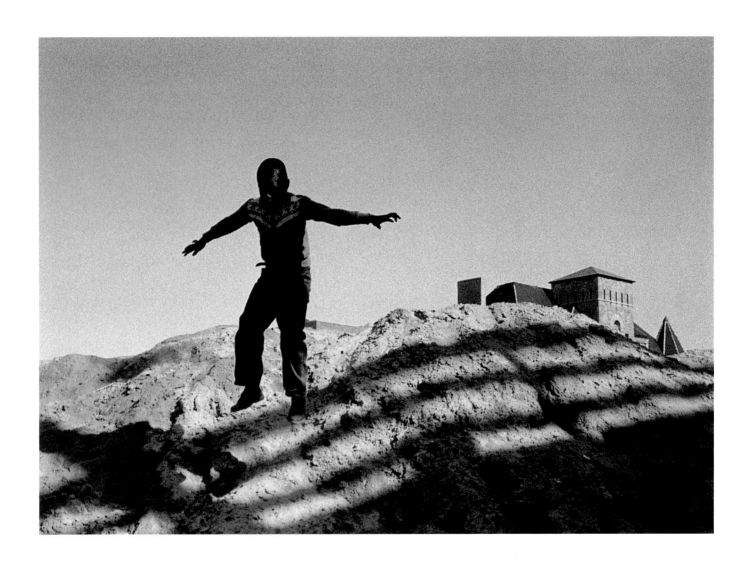

Chicago, 1950

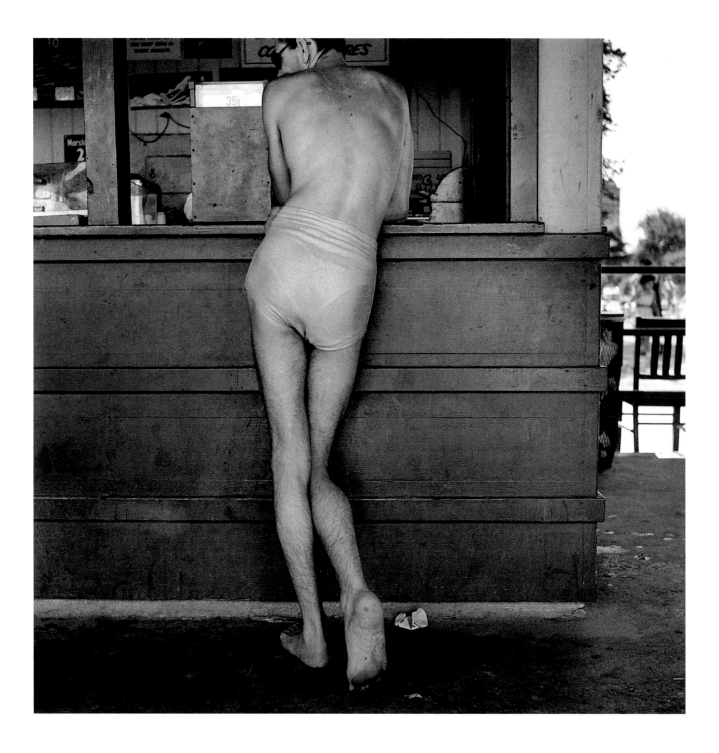

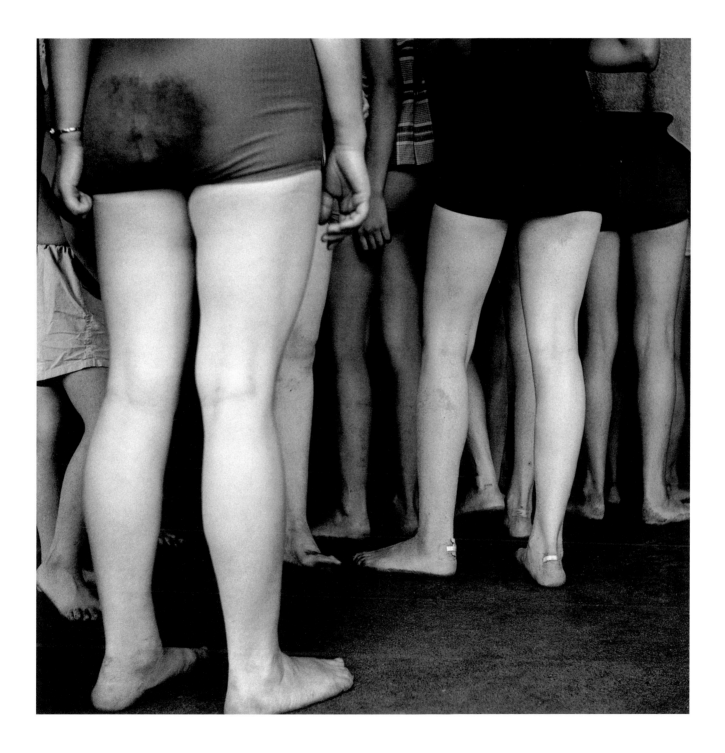

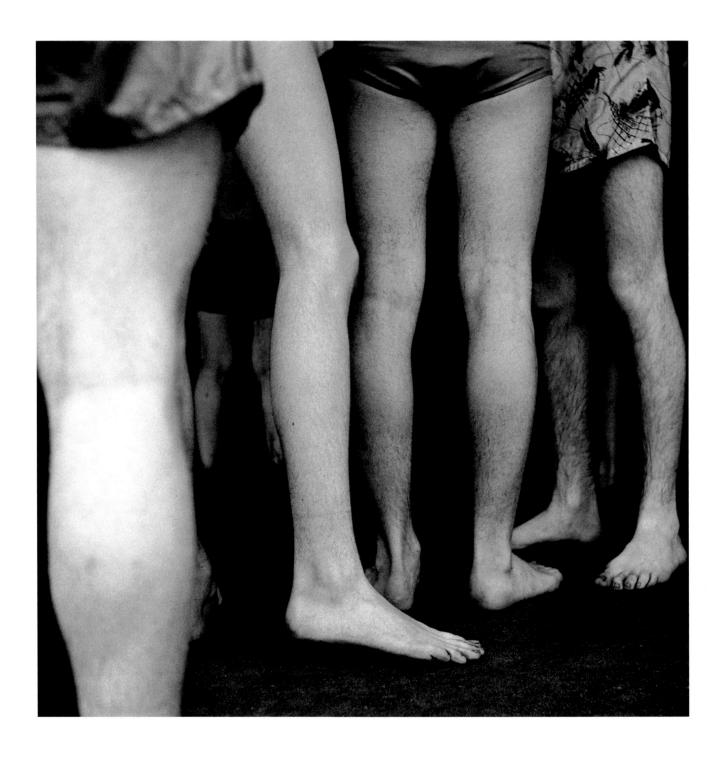

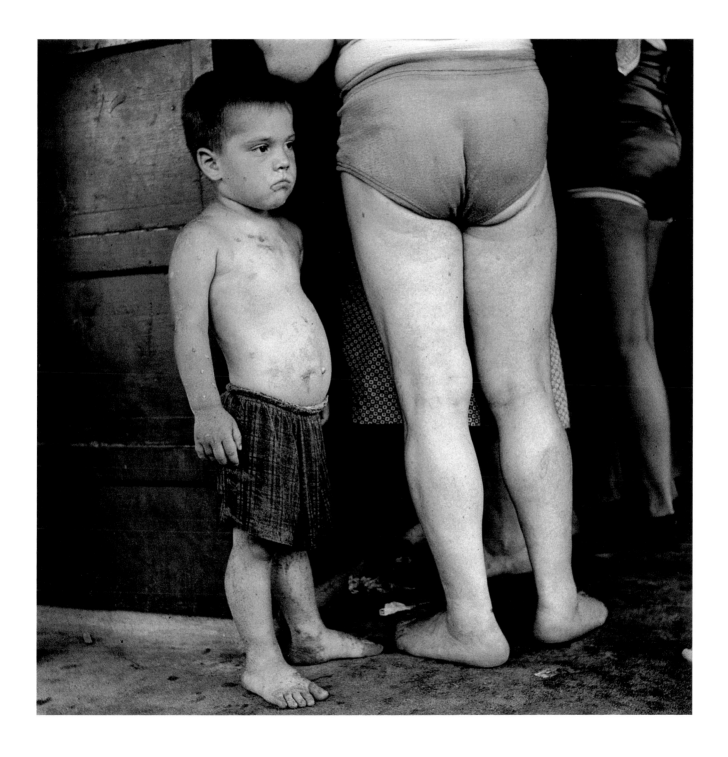

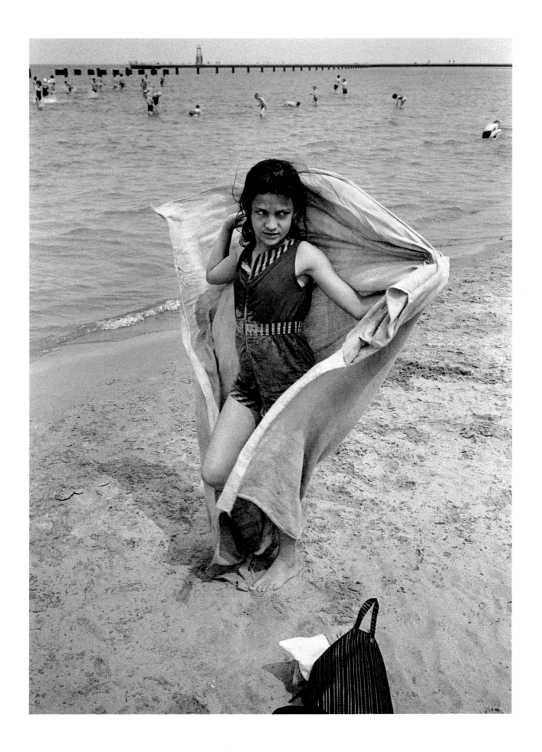

Chicago, 1960

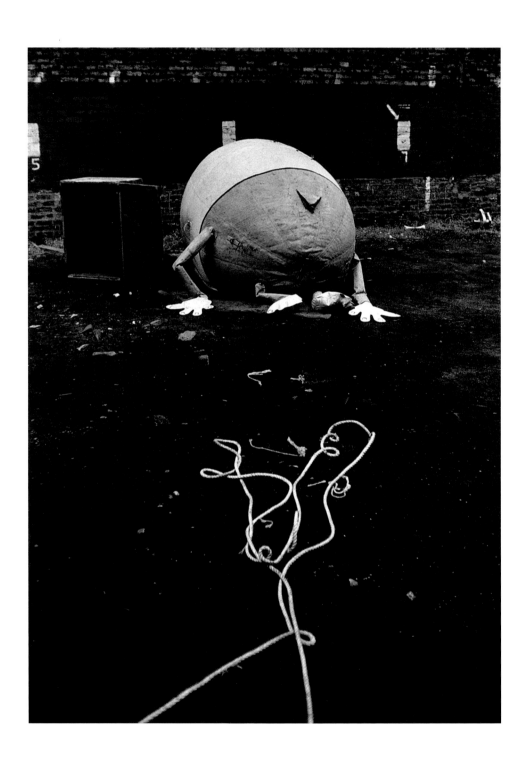

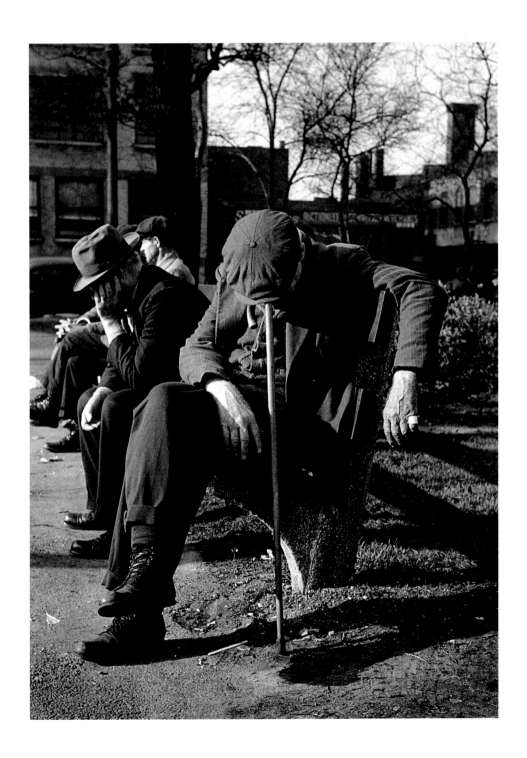

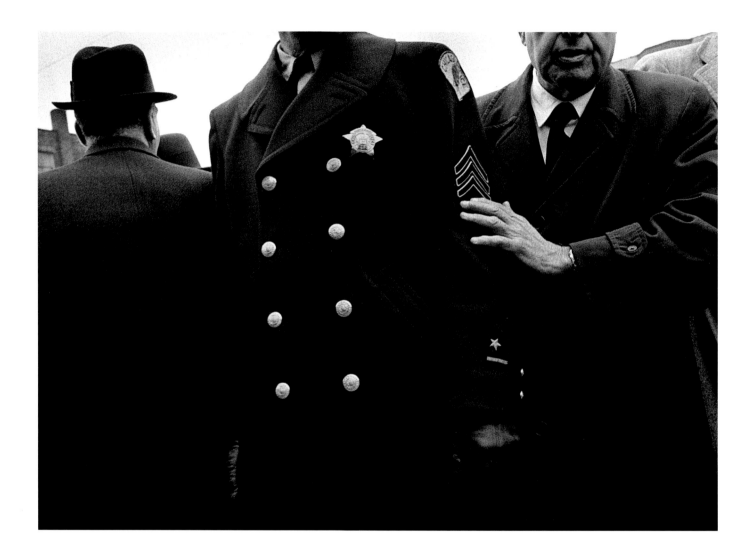

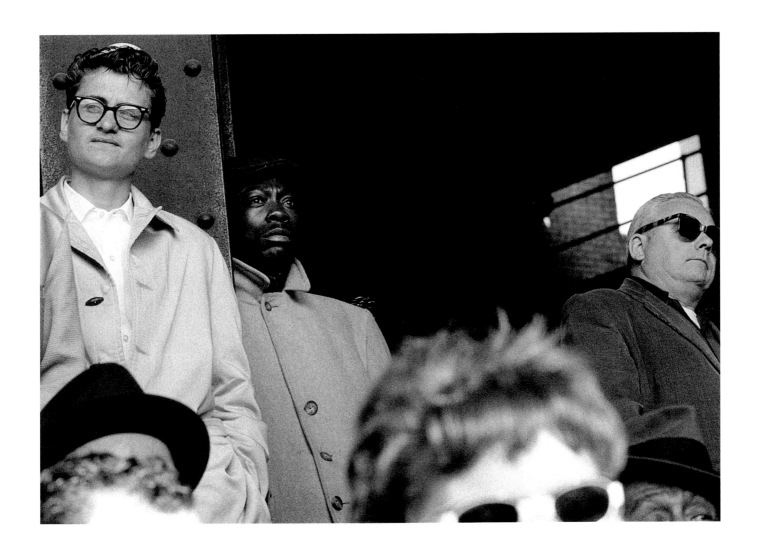

Chicago, 1959/61

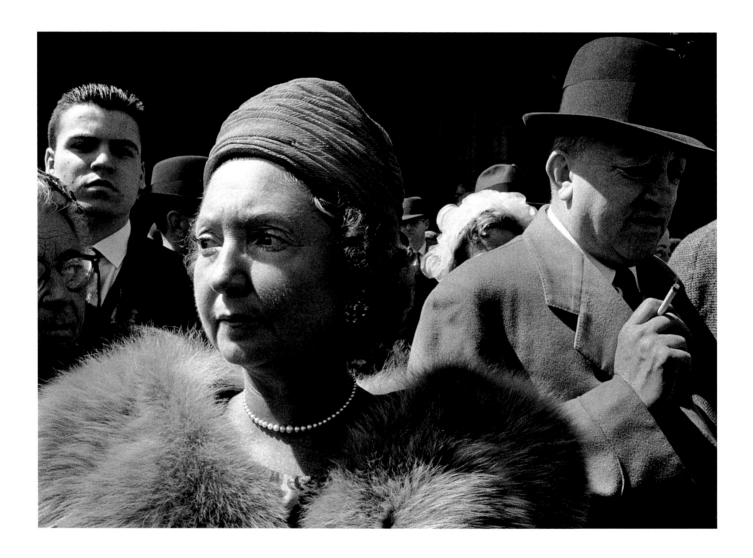

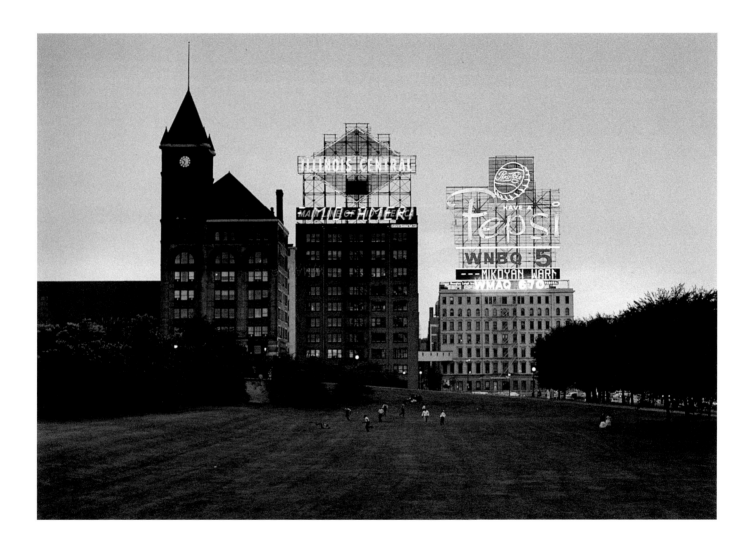

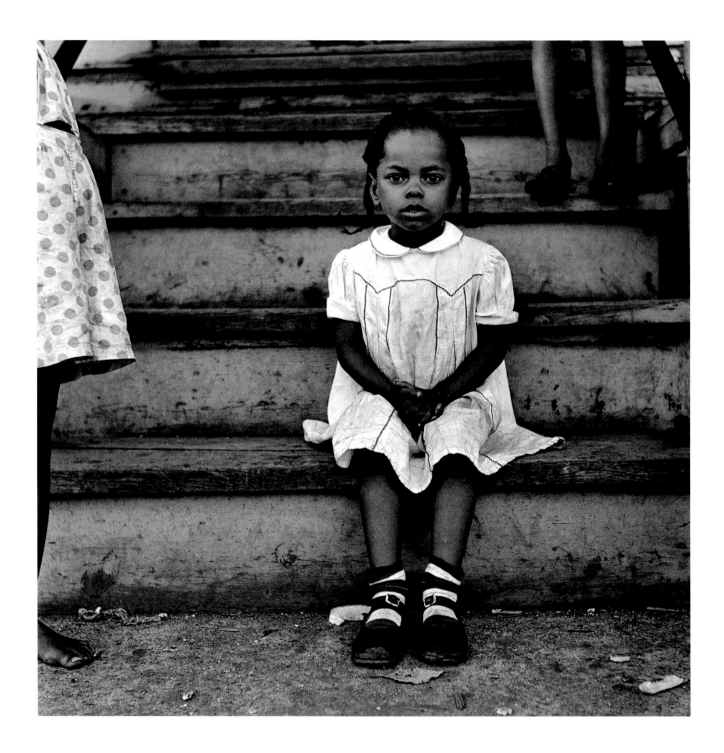

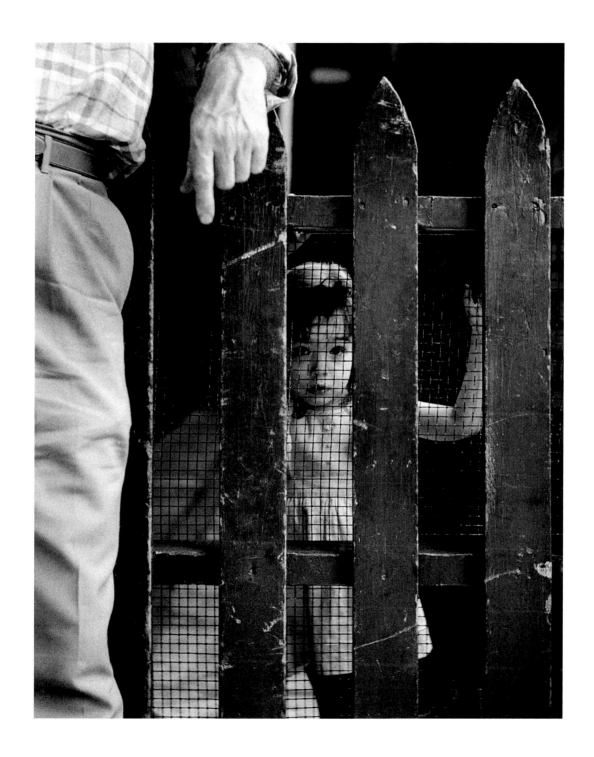

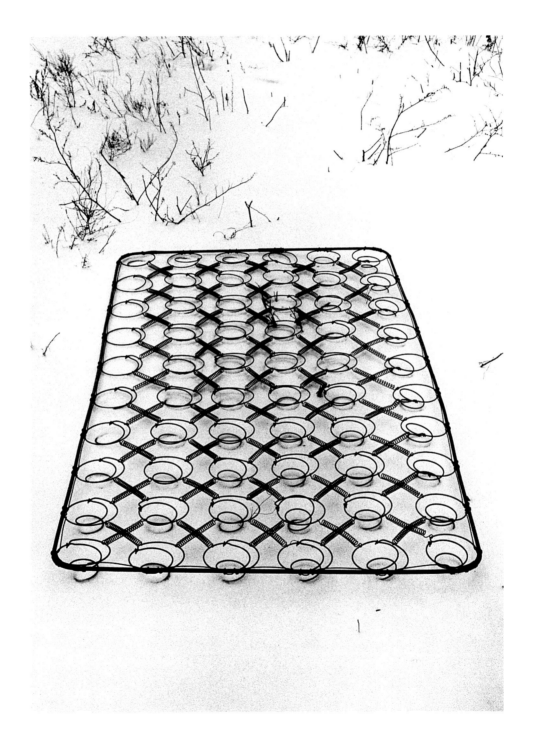

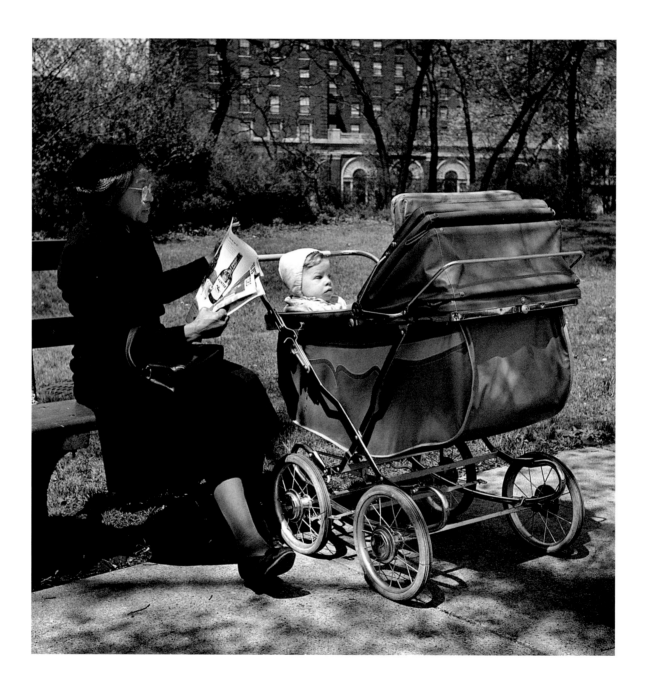

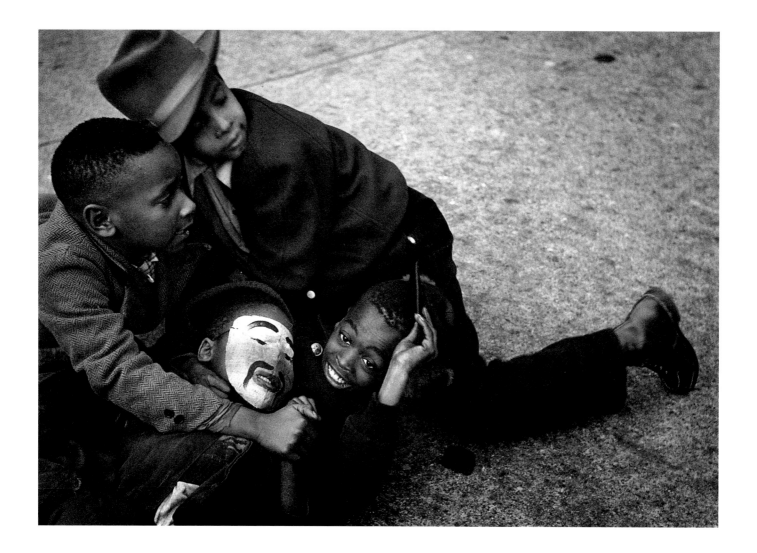

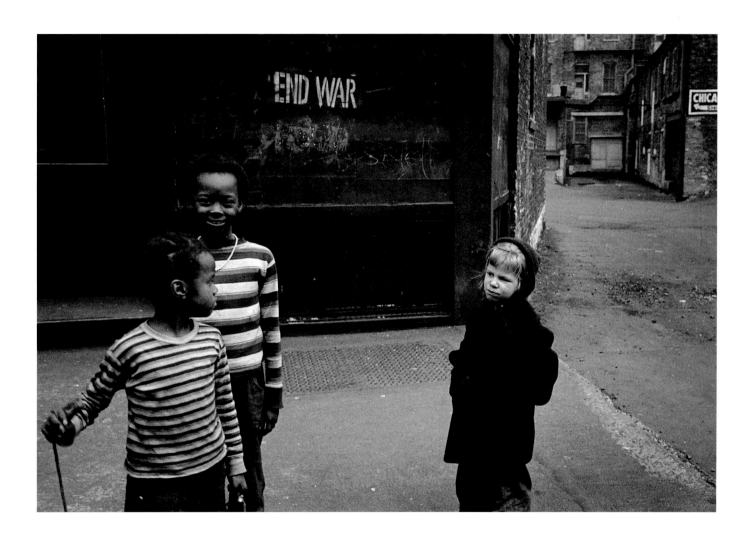

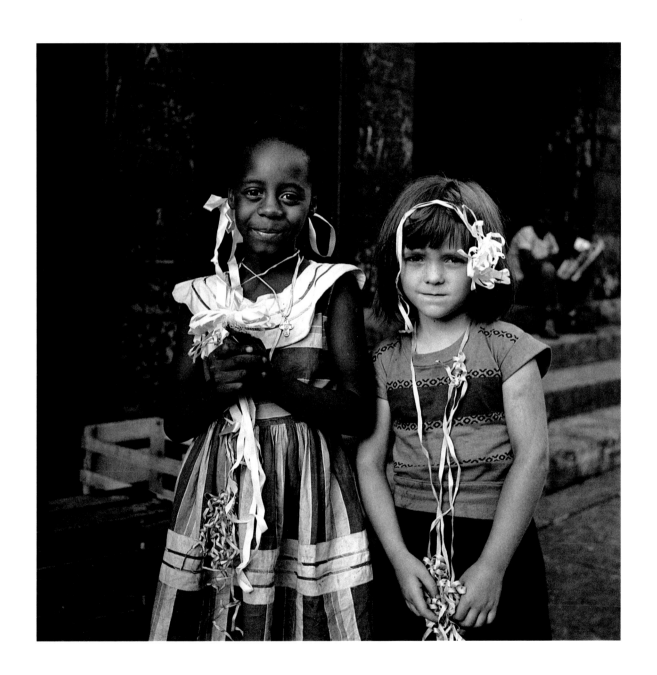

CHRONOLOGY AND SELECTED BIBLIOGRAPHY

Yasuhiro Ishimoto was born in San Francisco in 1921 to Japanese parents who returned to their homeland with him when he was three. In 1939 he came back to the United States to study agriculture at the University of California, San Diego, but his education was interrupted in 1941 when he was sent to the Amachi Internment Camp in Colorado. Released in 1945, he moved to Chicago to study architecture at Northwestern University. He soon turned his primary attention to photography, however, after joining the Fort Dearborn Camera Club and reading László Moholy-Nagy's *Vision in Motion.* In 1948 he entered the Institute of Design—which Moholy-Nagy had founded as the New Bauhaus—and studied photography under Harry Callahan.

Supporting himself as a silk-screen technician, Ishimoto was able to buy a movie camera and do a short documentary entitled *Maxwell Street* with fellow student Marvin Newman. While Ishimoto was still a student, Edward Steichen, curator of photography at the Museum of Modern Art, New York, also selected his work for the 1955 exhibition and catalogue *The Family of Man,* and he planned a separate exhibition at the Museum of Modern Art that Ishimoto was to share with two other photographers in 1961.

Having finished his degree in 1952, Ishimoto returned the following year to Japan, where he established himself as a photographer with a documentation of Katsura Villa done in 1954. From 1959 through 1961, he was back in Chicago with his wife Shigeru photographing on a fellowship from the Minolta Corporation. In 1960 he was given a one-man exhibition at The Art Institute of Chicago. Upon his return to Japan, he received appointments as a photography teacher at Kuwasawa Design School and the

Tokyo College of Photography (both 1962–66) and later at Tokyo Zokei University (1966–71).

Throughout the 1970s and 1980s, Ishimoto did both personal and commissioned work, receiving several distinguished awards in Japan. In 1989–90 he was given a retrospective at the Seibu Museum of Art, Tokyo, and in 1996 his most recent work was seen in a one-man exhibition at Tokyo's National Museum of Modern Art. The following year, the nation bestowed on Ishimoto the honor of making him a "Person of Cultural Merit," which includes a fellowship for life.

Although the bibliography below lists only books produced by Ishimoto himself and exhibition catalogues, his work has also been widely seen in journals and magazines published in Japan. For twenty years (1973–93) Ishimoto produced annual covers, in the form of color abstractions made in-camera, for the magazine *Approach.* From 1954 to 1976, his work appeared intermittently in *Camera Mainichi,* and during the period from 1963 to 1970, one or more feature pieces on Ishimoto were published in that journal each year. Other prominent Japanese photographic journals in which his photographs have been featured include *Camera Geijyutsu* (1954), *Photo Art* (1965), and *Asahi Camera* (1971).

Ishimoto's bibliography of photographic books is studded with topics to which he has returned, sometimes under the same title, years after publishing his initial work. The most salient examples are *Chicago, Chicago,* first published in 1969 and then done again with different pictures in 1983, and *Katsura,* his first book on which was a collaboration with modernist architect Kenzo Tange, while the second was done with post-modernist Arata Isozaki.

Fig, 1. Cover of *Someday, Somewhere* (1958)

Fig. 2. Cover of *Katsura: Tradition and Creation in Japanese Architecture* (1972)

Fig. 3. Cover of *Chicago, Chicago* (1969)

Fig. 4. Cover of *Ise Shrine* (1995)

1

3
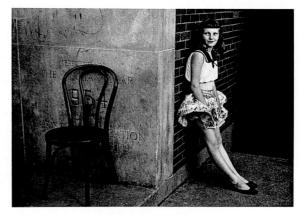

2
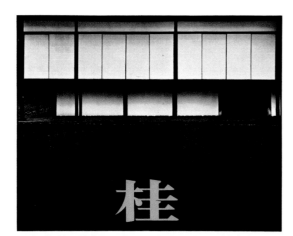

4
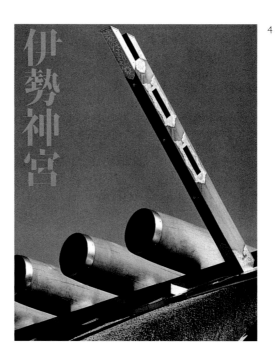

I. MONOGRAPHS BY YASUHIRO ISHIMOTO

Ishimoto, Yasuhiro. *Someday, Somewhere*. With a foreword by Tsutomu Watanabe. Tokyo: Geibi Shuppansha, 1958.

Ishimoto, Yasuhiro, Kenzo Tange, and Walter Gropius. *Katsura: Tradition and Creation in Japanese Architecture*. Tokyo: Zokeisha Publications, Ltd., 1960; New Haven: Yale University Press, 1960.

Ishimoto, Yasuhiro. *Chicago, Chicago*. With a foreword by Harry Callahan. Tokyo: Bijutsu Shuppansha, 1969.

Ishimoto, Yasuhiro, and Kenzo Tange. *Katsura: Tradition and Creation in Japanese Architecture*. Tokyo: Zokeisha Publications, Ltd., 1971; New Haven: Yale University Press, 1972.

Ishimoto, Yasuhiro. *The Mandalas of the Two Worlds at the Kyoo Gokoku-ji in Kyoto*. Tokyo: Heibonsha, 1977.

————. *Islam: Space and Design*. Tokyo: Shinshindo, 1980.

————. *Kyoto Rock Garden*. Tokyo: Kodansha, 1980.

Ishimoto, Yasuhiro, and Arata Isozaki. *Katsura Villa: Space and Form*. Tokyo: Iwanami Shoten, 1983; New York: Rizzoli, 1987.

Ishimoto, Yasuhiro. *Chicago, Chicago*. Tokyo: Japan Publications, 1983.

Ishimoto, Yasuhiro, and Akio Matsumoto. *Handicrafts of Kyoto*. Tokyo: Gakugei Shorin, 1988.

Ishimoto, Yasuhiro. *Flowers*. Tokyo: Kyuryudo Art Publishing, 1988; San Francisco: Chronicle Books, 1989.

Ishimoto, Yasuhiro, Arata Isozaki, and Eizo Inagaki. *Ise Shrine*. Tokyo: Iwanami Shoten, 1995.

Ishimoto, Yasuhiro. *Ishimoto Yasuhiro*. Tokyo: Iwanami Shoten, 1997.

II. EXHIBITION CATALOGUES

The Seibu Museum of Art. *Eros + Cosmos in Mandala: The Mandalas of the Two Worlds at the Kyoo Gokoku-ji*. Tokyo, 1978.

The Seibu Museum of Art. *The Photography of Yasuhiro Ishimoto: 1948–1989*. With an essay by Fuminori Yokoe. Tokyo, 1989.

National Museum of Modern Art. *Yasuhiro Ishimoto: Remembrance of Things Present*. With essays by Masanori Ichikawa and Rei Masuda. Tokyo, 1996.

Tokyo Metropolitan Museum of Photography. *Yasuhiro Ishimoto: Chicago and Tokyo*. With an essay by Akiko Okatsuka and interviews with Shigeru Ishimoto, Kiyoji Otsuji, and Tadasuke Akiyama. Tokyo, 1998.

THE CALL OF THE OCEAN OF MEMORY

FUMINORI YOKOE

During the fifty years that Yasuhiro Ishimoto has been involved in artistic creation, he has remained true to his principles, never once allowing himself to waver. Ishimoto has said that this is due to the consistency to be found in the "environment" that surrounds all of us. His approach to photography, however, has altered in correspondence with the internal changes Ishimoto has undergone, demonstrating that he continues to possess a free and fresh critical spirit.

What kind of process is involved in the creation of his work and what meaning can we draw from it? When we consider these questions, it becomes clear that the relationship between memory and image plays an important role for him. After he has shot a scene and processed the film, Ishimoto leaves the entire project alone for some time. This period might be a few weeks, or, again, it might even be a few years. During this interval of time, Ishimoto thinks back to the image he had when he took the shot, bringing it to mind from time to time and letting it mature while he considers the best method of expressing it. When his thoughts reach the point of crystallization in his mind, it is time for him to work on the print. As Ishimoto sees the image appear on the paper, the memory of its creation comes back to him and gradually becomes transformed into art. In other words, the recollection of something freshly experienced is not a real memory: Ishimoto believes that it takes time for a person's experiences to mature into true memories.

What is a primal scene for Ishimoto? It can be said to represent a subconscious memory, a kind of meeting with "something."

Ishimoto was born in 1921 in San Francisco to Japanese parents and at the age of three moved with his family to live in Kochi Prefecture, Japan. At eighteen, he returned alone to the U.S. to enter the University of California. Thus, fifteen of his most formative years were spent in Japan. It would hardly seem necessary to point this out, except for the fact that it has long been a subject of some discussion and dispute. When Ishimoto was given an exhibition at The Art Institute of Chicago in 1960, the photographer and critic Minor White prepared a brief essay for the museum's brochure in which he said, "Yasuhiro Ishimoto is a visual bilingualist: Japanese by heritage, his traditions of seeing are Oriental; Western by schooling at the Chicago Institute of Design (the contemporary center of the Bauhaus tradition), he speaks visual English with a German accent." Upon reading White's comments, Ishimoto remarked, "It is true that I studied at the New Bauhaus in Chicago, so I agree that my work can be said to contain American and German influences, but I do not agree that I have any Japanese traits." He asked White to remove this particular statement from his text, but the changes he requested were not made. Nevertheless, looking back over the interval of years, Ishimoto is ready to admit the validity of White's observations: there is indeed a Japanese side to his character.

Among the various influences on him in the U.S. was Gyorgy Kepes's book *Language of Vision* (1944), which Ishimoto came across by chance in a bookstore shortly after he began photographing in Chicago in the postwar era. Another major influence was surely László Moholy-Nagy's *Vision in Motion* (published posthumously in 1947). Both of these books directed Ishimoto's attention to Chicago's Institute of Design (founded in 1937 as the

Fig. 1. From *Handicrafts of Kyoto* (1988), pp. 136-37

Fig. 2. Tokyo, 1987

Fig. 3. Tokyo, 1995

1

2

3

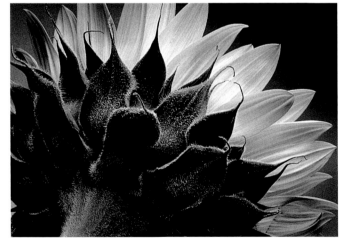

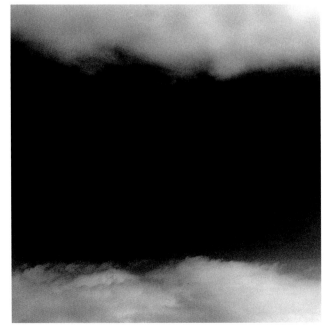

New Bauhaus), and his four years of study there certainly had enormous impact on him.

Returning to Japan in 1953, Ishimoto made his debut on the Japanese photographic scene. In his work he developed the aesthetics he had picked up during the fourteen years he spent in America from the age of eighteen, and he combined that personal aesthetic with the way of looking, thinking, and composing that he had learned at the Institute of Design. He would study his subject with an impassive eye that left no room for Japanese sensitivity, showing clearly that the creativity and philosophy he used to capture it could only be gained through the penetration of the essence of matter. His work in Japan continued to adhere to these principles, making him unique in the Japanese photographic world.

The power of his gaze to penetrate his subject is illustrated in the book *Handicrafts of Kyoto* (1988), in which he photographed beautifully refined, traditional objects created by the craftsmen of that ancient city. Ishimoto discovers in his subjects a rationalism contained within their functional shape and shows them together with the hands of the artisans (see fig. 1).

During the last ten years or so, he has focused on several subjects that represent the theme of "transitory objects" (see figs. 2–5). His photographic exploration of this broad subject includes clouds that change from moment to moment; fallen leaves that have been soaked by rain and then trodden into the earth; empty cans that have been run over by automobiles, losing their shape and merging into the ground; and, finally, footprints in the snow that other people have walked over, or that have been melted by the sun, changing their shape.

The Ise Shrine in Mie Prefecture is said to have been first constructed in the third century, but it has constantly been rebuilt every twenty years since then. From the time that Ishimoto started photographing it, he felt that rather than eternity, this constant renewal creates a form of continuous "life." In this context, he tries to capture the "nature of time" in things that are not fixed, that change, that disappear. In this respect, therefore, it can be said that his "clouds" and "Ise" are, in a way, the same, and the photographs of them exist as a "contemporary memory" of things that disappear.

At present, Ishimoto is reviving a project begun many years ago on the Yamanote train line in Tokyo (see fig. 6). Life in Tokyo, of course, contains numerous problems and contradictions, and in many ways it can be considered to be a microcosm of the state of Japan. In presenting these photographs, Ishimoto hopes to make the people who see them realize their predicament and consider the immediate environment that surrounds them. At the same time that they recognize this, his pictures are intended to make them consider how they should live together with nature and look towards the larger environment as a whole.

When we look at these photographs, they bring to the brink of memory things that are impossible to recall. Ishimoto's work has this ability.

Naturally, of course, the kinds of memories that a single person can recall vary from one individual to another; there are also temporal differences between our abilities to recover old memories as opposed to new ones. But an image held in memory does not have any actual form of its own; we retain it in a uniquely personal way, and

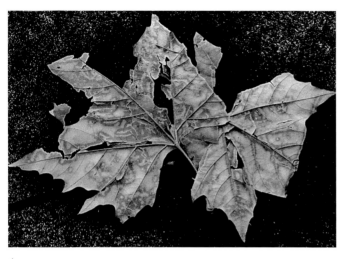

4

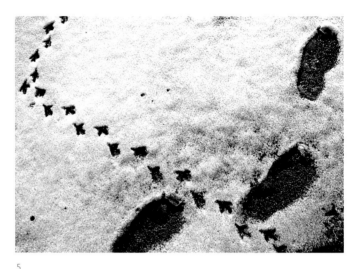

5

Fig. 4. Tokyo, 1992

Fig. 5. Tokyo, 1987

Fig. 6. Tokyo, 1967

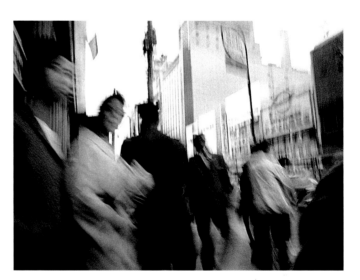

6

this may be what makes it appear so real. Again, memory itself has no order; there is no concept of time that controls it. For this reason, it possesses a detailed realism that cannot be explained dialectically.

In 1932 the magazine that is said to have contributed to the establishment of modern Japanese photography, *Koga,* was first published. In the first edition, the up-and-coming critic Ina Nobuo contributed an article entitled "Return to Photography," in which he urged people to bid farewell to pictorialism and discard all notions of established art forms to create a set of new aesthetics for photography, bearing in mind the "mechanical nature" of this unique medium. He stressed the importance of the person behind the camera, and he closed his essay with this remark: "In order to offer the highest form of expression to the 'contemporary world,' it is necessary for the person who holds the camera to be a member of society, in the highest meaning of the word." By "member of society" he meant not merely a person with a social existence, but someone with a personal vision and a unique critical spirit—a person with a modern identity.

In a world where information is becoming ever more complicated, Ishimoto feels that we have lost something important: that is to say, our humanity. He acknowledges that there is no going back to what once was, and yet he fears that we will be so crushed by the volume of information and the pressure of time that we will no longer be able to see the true character of anything. Through his work, he questions the status quo, purposefully, yet quietly.

Translated from the Japanese by Gavin Frew.

YASUHIRO ISHIMOTO'S "KATSURA": A NEW MECHANISM OF READING

ARATA ISOZAKI

The first major project that Yasuhiro Ishimoto embarked upon after his release from the wartime internment camps and the completion of his studies at Chicago's Institute of Design was to photograph the Katsura Detached Palace in Kyoto, Japan, in the early 1950s. Until this time, architectural photography in Japan had been concerned solely with capturing an object with precision and accuracy; no one expected that it be more than a record.

But the Katsura that Ishimoto captured was something very different (see fig. 1). First, it was broken up into the smallest possible details: the horizontal and vertical lines where the black pillars and rafters crossed; the light-emitting *shōji* and the white surface of the walls. There a compositional screen emerged in which the strict proportions between two elements evoked abstract painting. Then there were the stepping stones, the moss, the sideboards with their wood grains, and the skin of the bamboo, all reduced to textural proportions to exude a sense of transparency.

These photographs of Japanese architecture, which seemed to take monochrome representation to its furthest limits, came as a bracing shock to architects when they were first published, for they seemed to offer a direct visualization of the kind of ideal that architects were then striving for. It had of course already been pointed out that Katsura could be a model not just for classical but also for modern architecture, but this was the first time that there were pictures to prove it.

Twenty-five years later, the Katsura Villa was disassembled and put back together again. Ishimoto took this opportunity to photograph it once more. Anyone who remem-

bers the earlier photographs is sure to wonder whether this is the same Katsura. If Ishimoto's initial effort could be said to represent a modernist reading of Katsura, this more recent exercise would merit the appellation "de-modernist." The final product is evidently the result of certain theoretical and technical transformations that Ishimoto has undergone over the last quarter century.

The most obvious difference to note between the two Katsura projects is that these newer photographs are all in color (see fig. 2). The use of color photography allows for the inclusion of much more information on the same surface area. In place of the method used for monochrome photographs, where only the barest elements are distilled from the disassembled object, Ishimoto, working in color, considers the object amidst a vast expanse in which even the various relationships in the background can be apprehended. The point here is not exclusion but inclusion. The conscious application of this method sheds light even on those elements of Katsura that would otherwise be obscured.

Right alongside the transparent character of Katsura, with its normatively modernist lack of ornamentation and abstractness, we also find ostentatious decoration and alluring spaces coupled with a multitude of heterodox designs that might even be called opaque. These are the elements of Katsura that have once again been brought to light. Ishimoto's second reading of Katsura, brought out by exploiting the full potential of color photography, is further supported by a masterly photographic technique that brings us an unprecedented image of the site.

At the same time, these more recent photographs show us how Ishimoto's thinking has, over the past few

decades, outstripped the narrow confines of a limited modernism to embrace a new vision of design capable of incorporating a far wider array of elements. For lack of a better term, I have chosen to call this new vision "de-modernist." At the very least we can say that Ishimoto has put together a new mechanism of reading through which the Katsura Detached Palace emerges before our eyes utterly restored and more fetching, more gorgeous than we had ever imagined.

Translated from the Japanese by Keith Vincent.

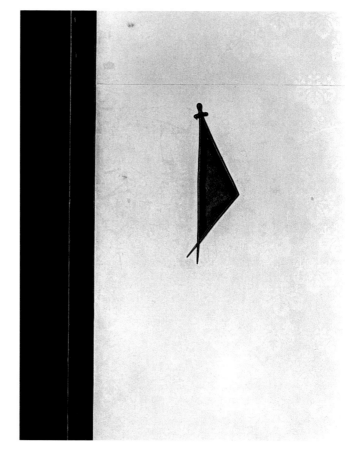

Fig. 1. Katsura Villa, 1954

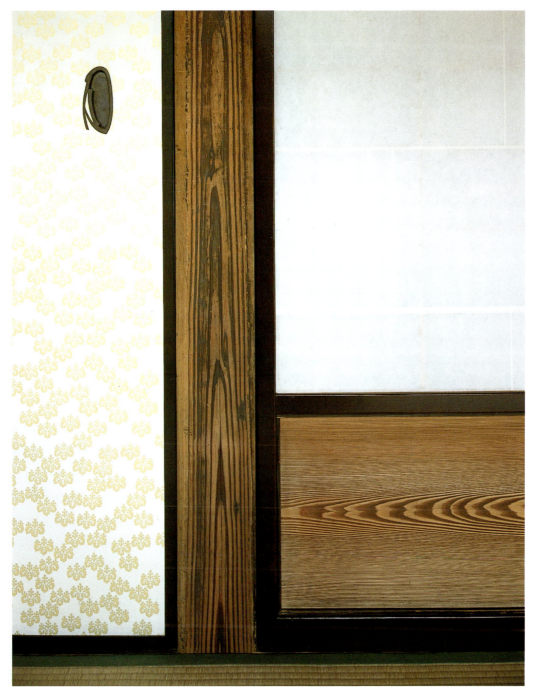

Fig. 2. Katsura Villa, 1982

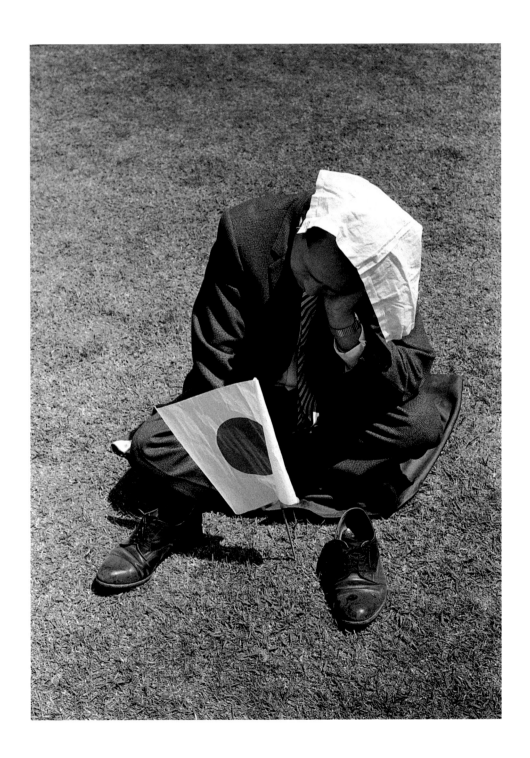

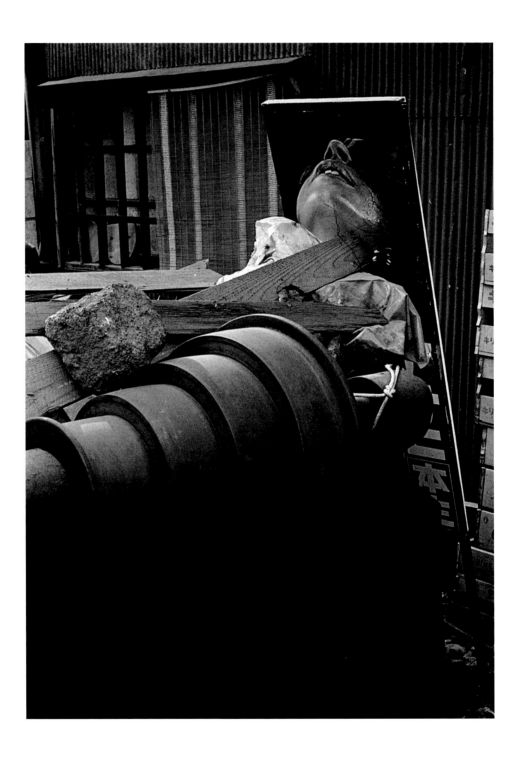

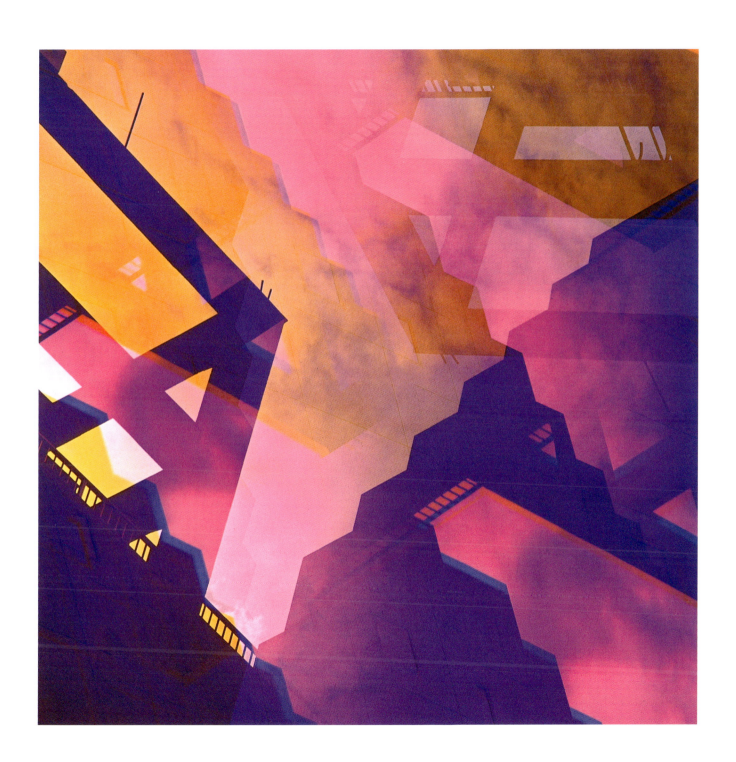

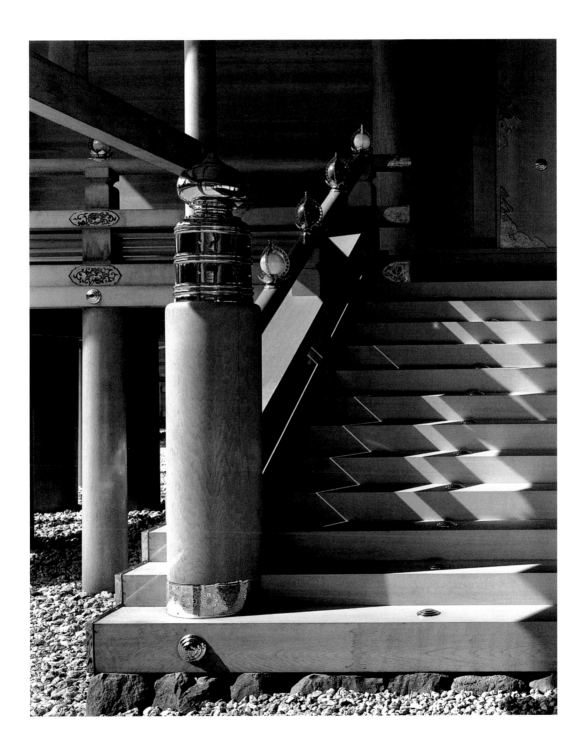

Tokyo, 1955/56

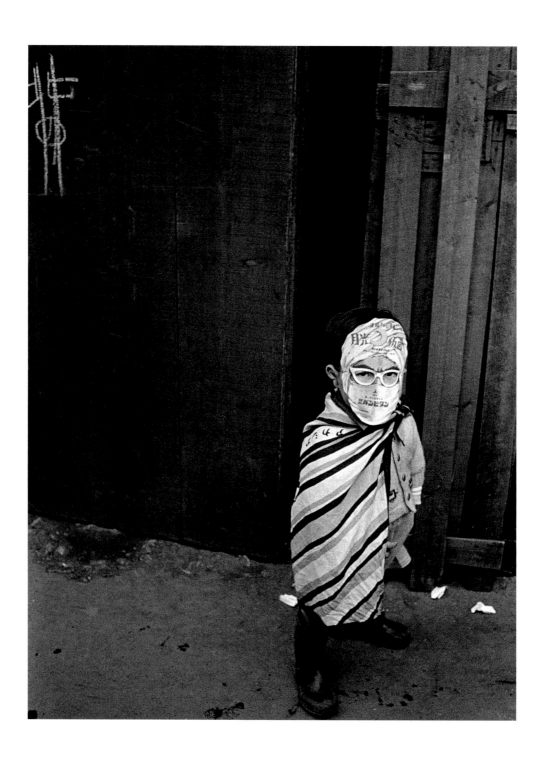

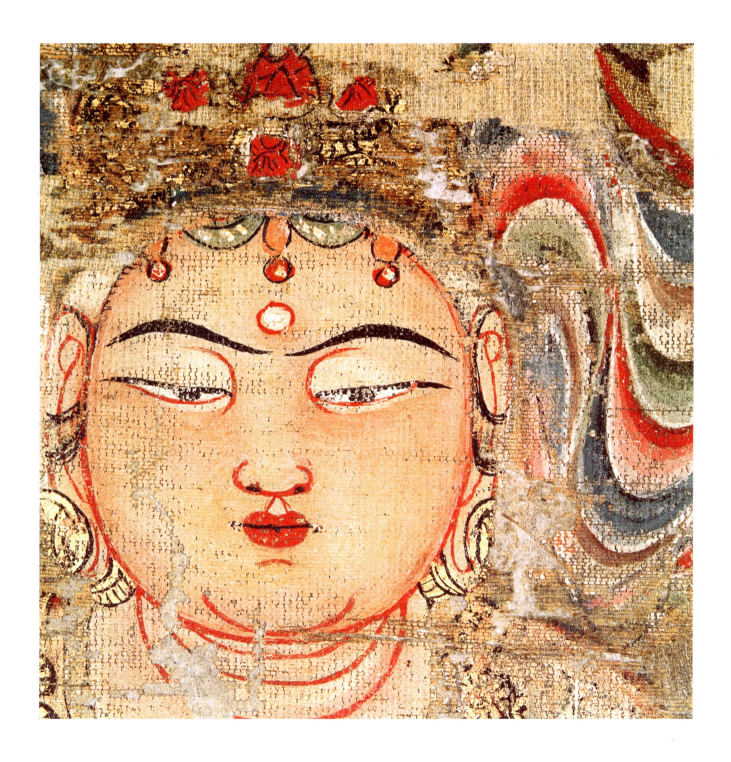

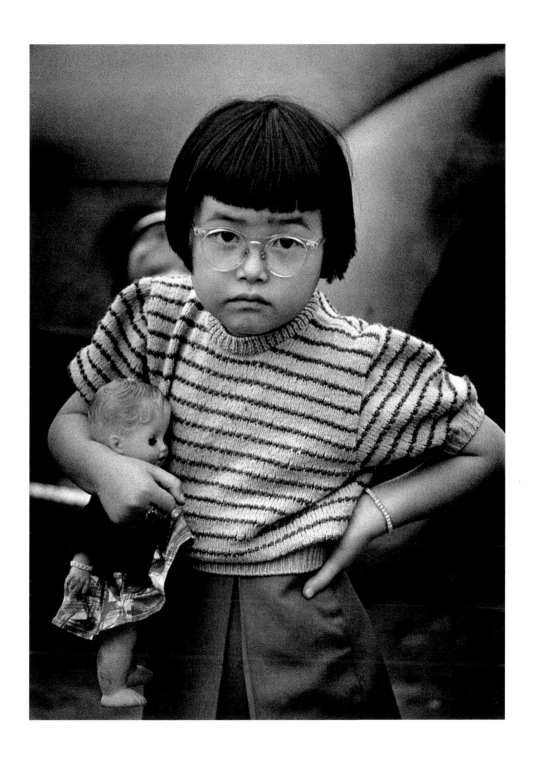

Tokyo, 1973/93

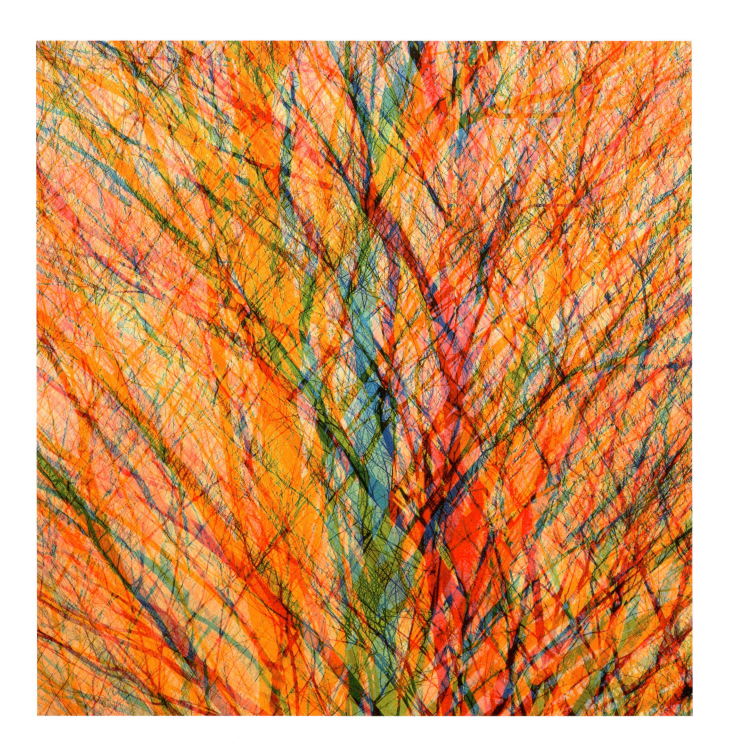

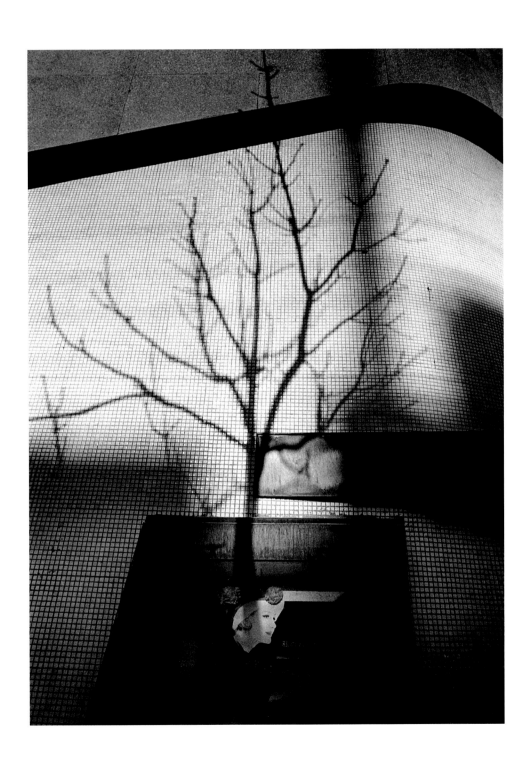

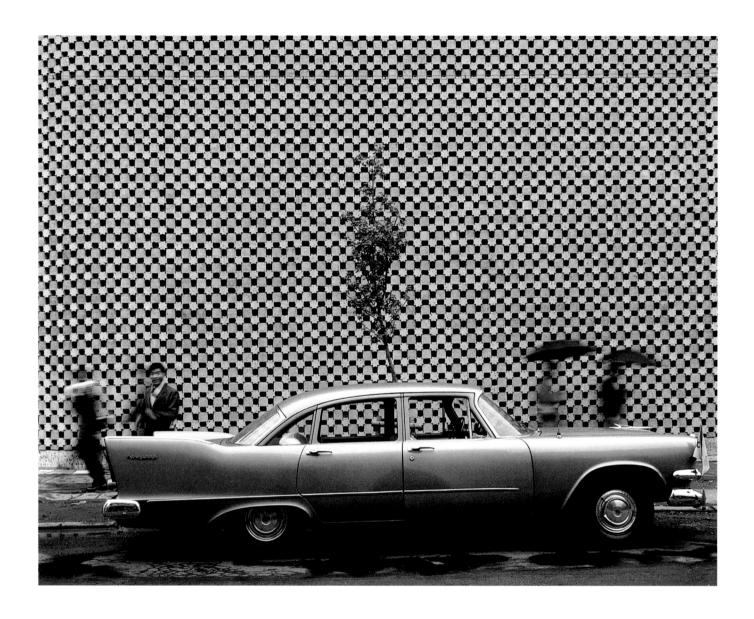

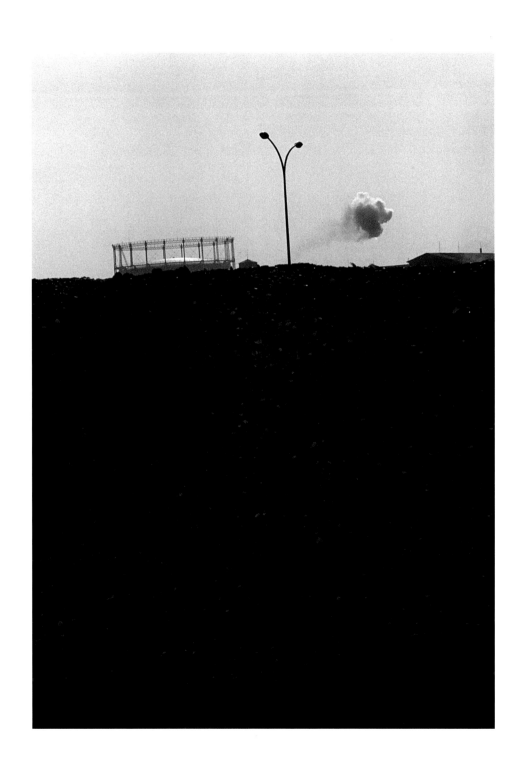

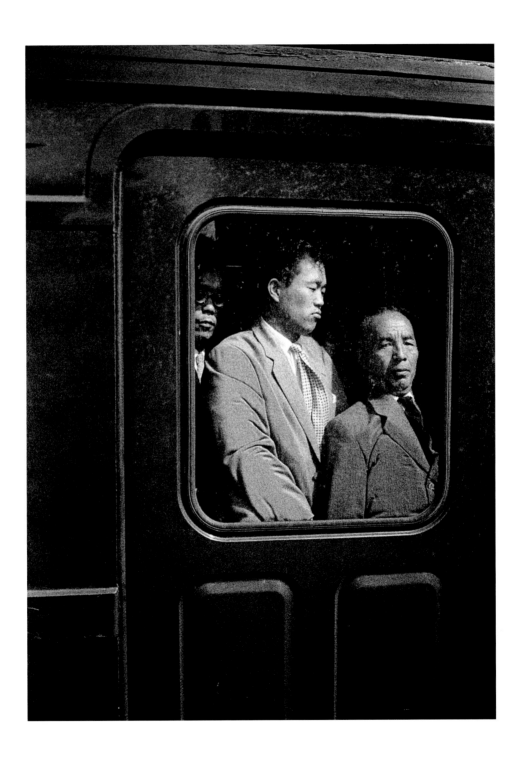

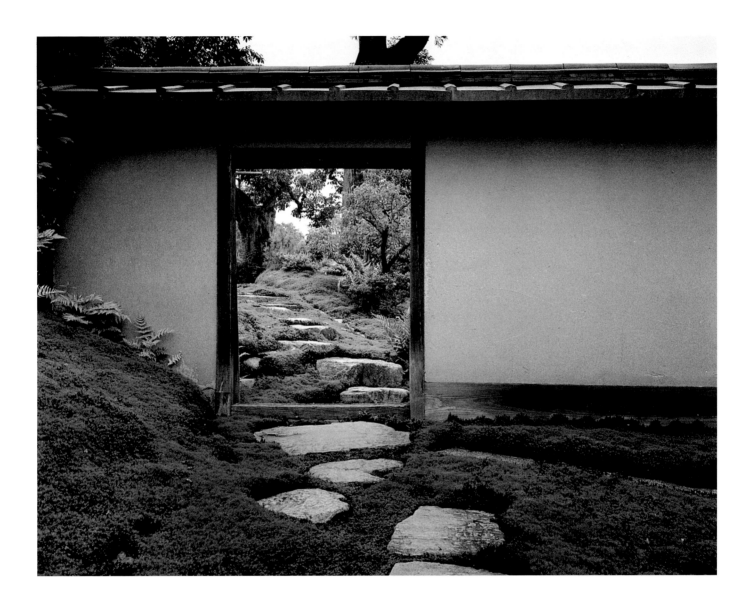

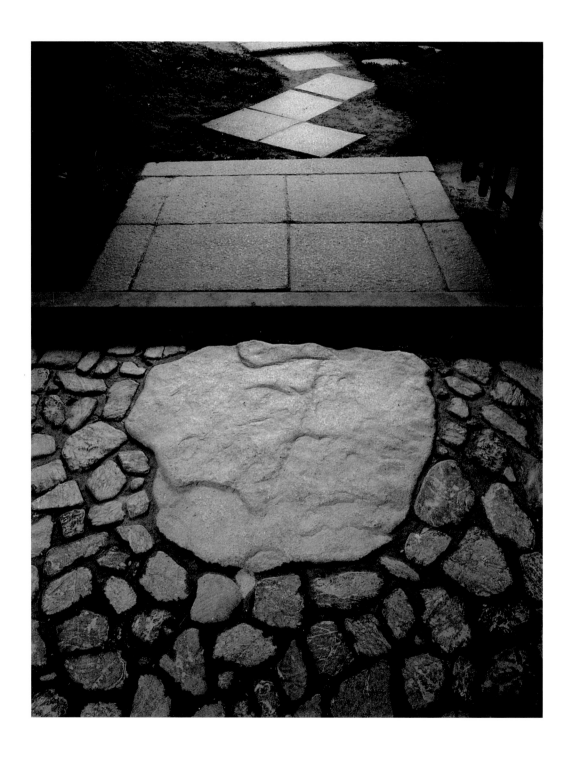

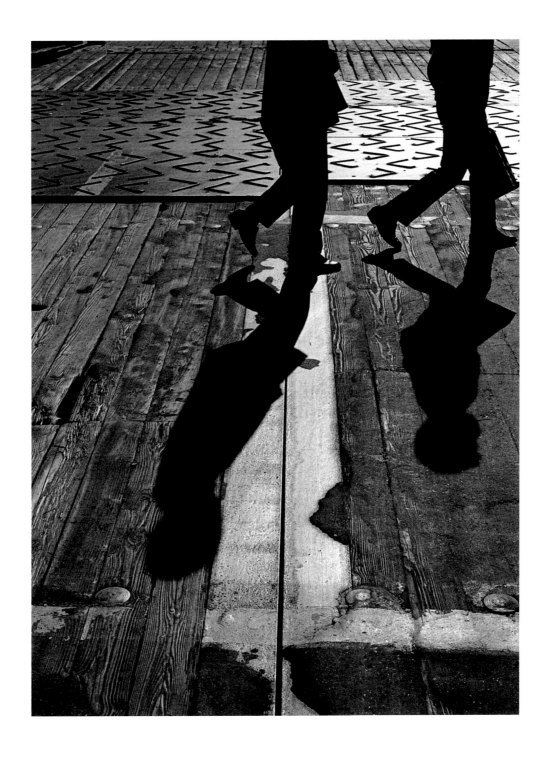

Tokyo, 1987/89

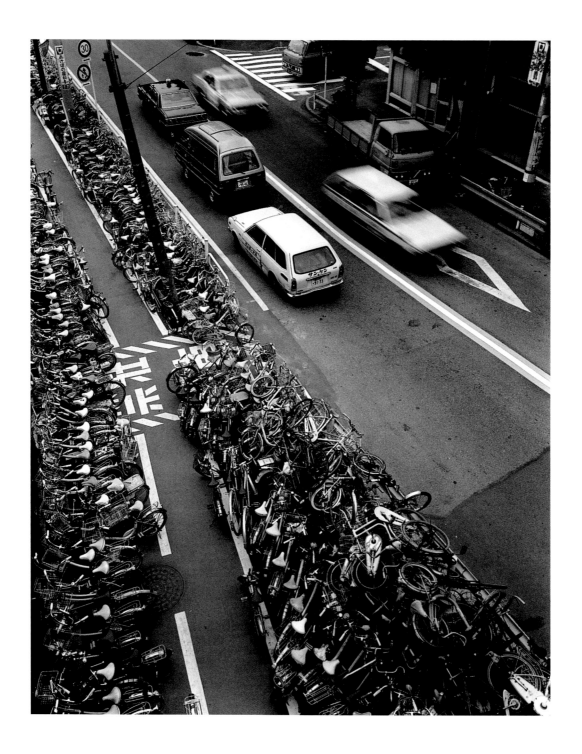

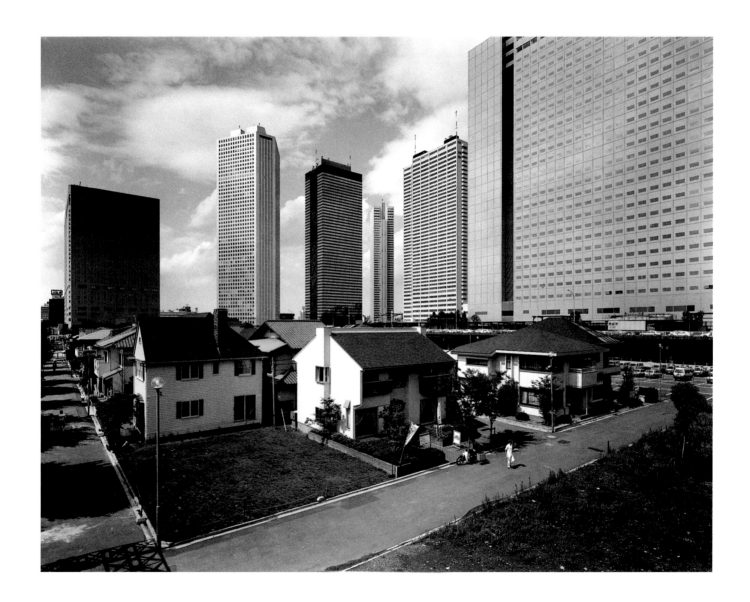

Tokyo, 1986

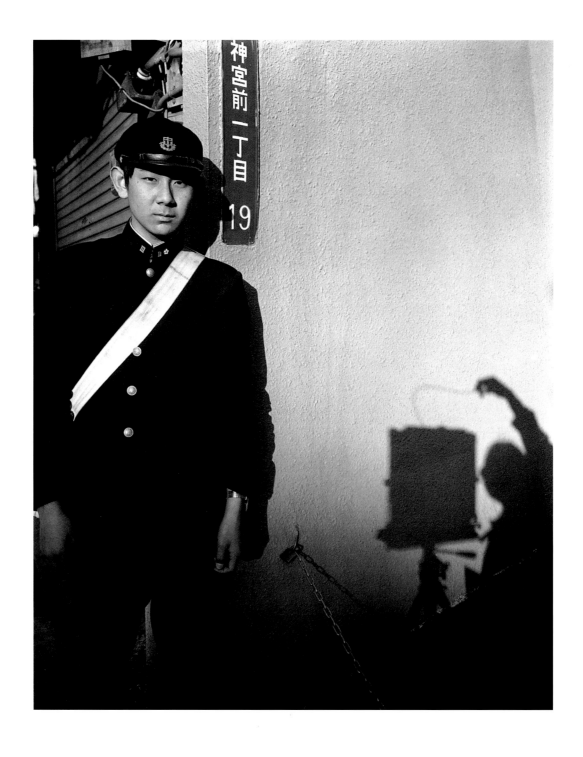

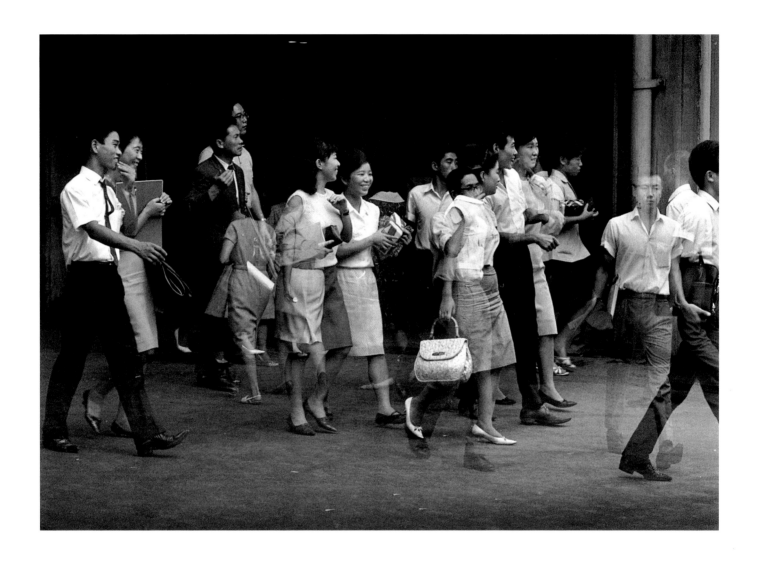

Tokyo, 1996

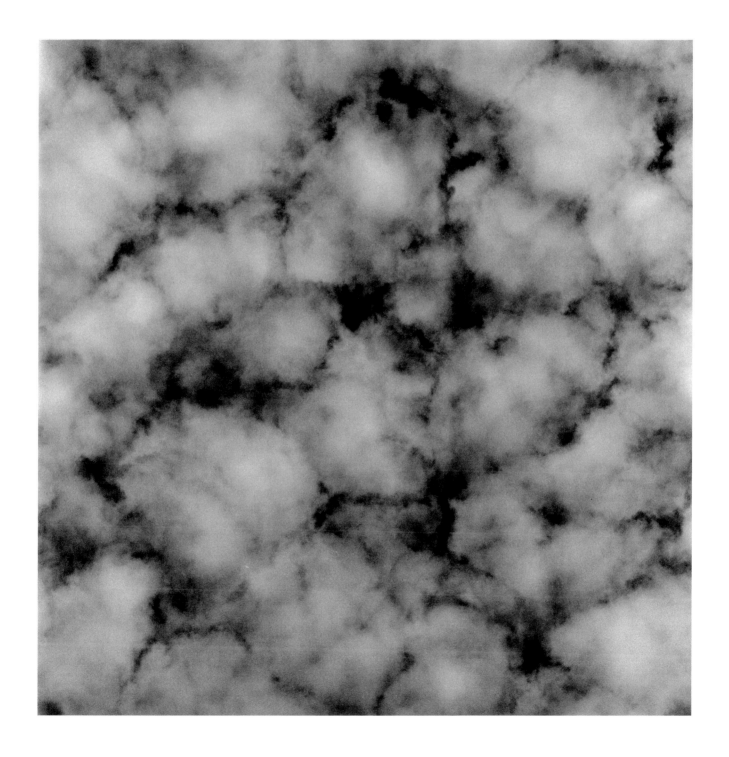

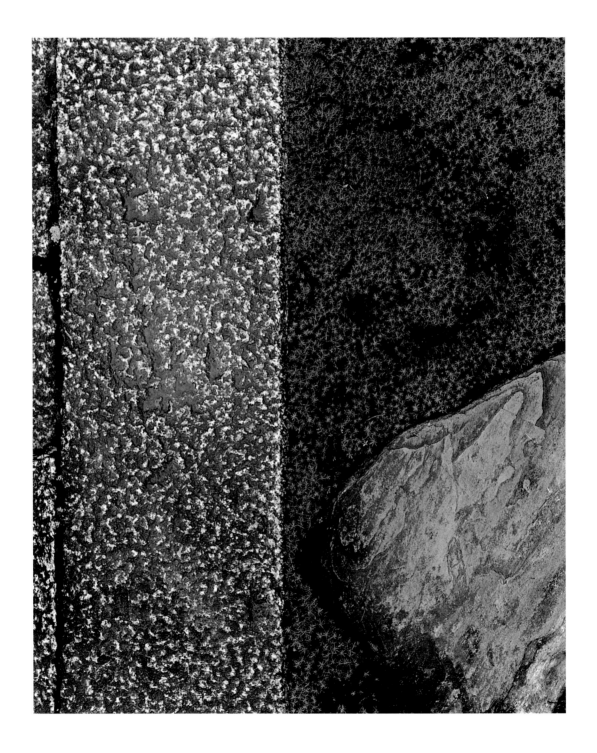

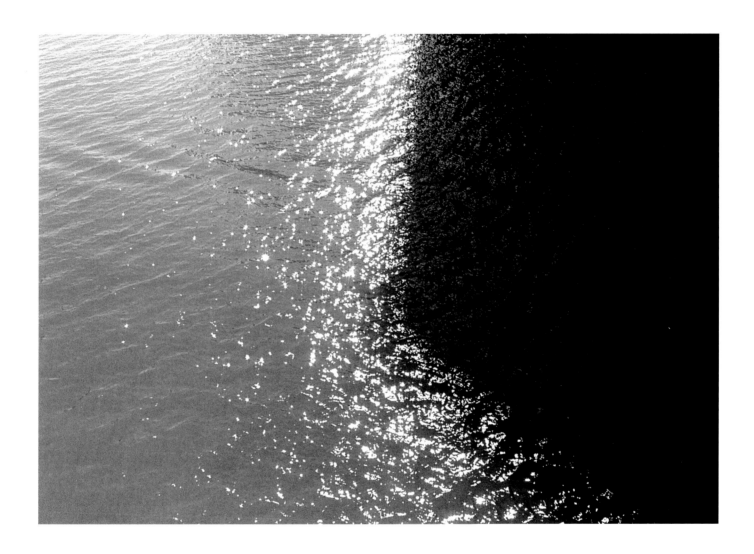

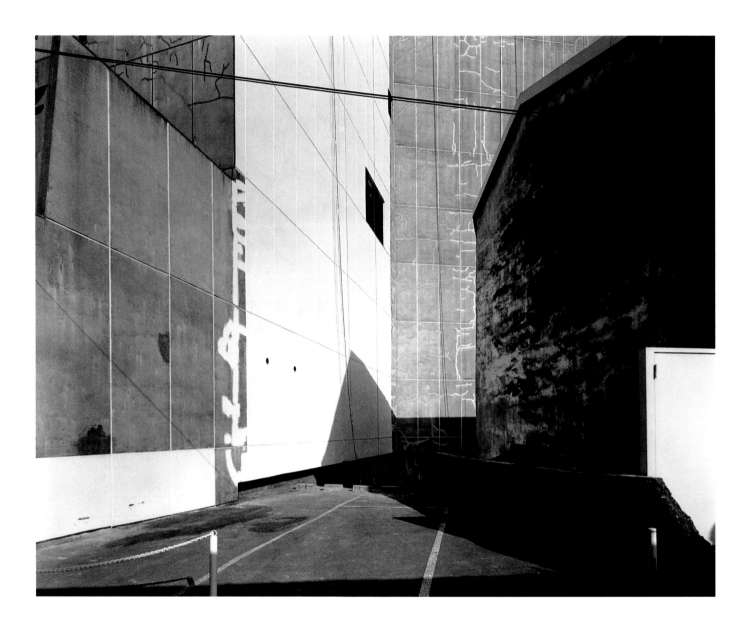

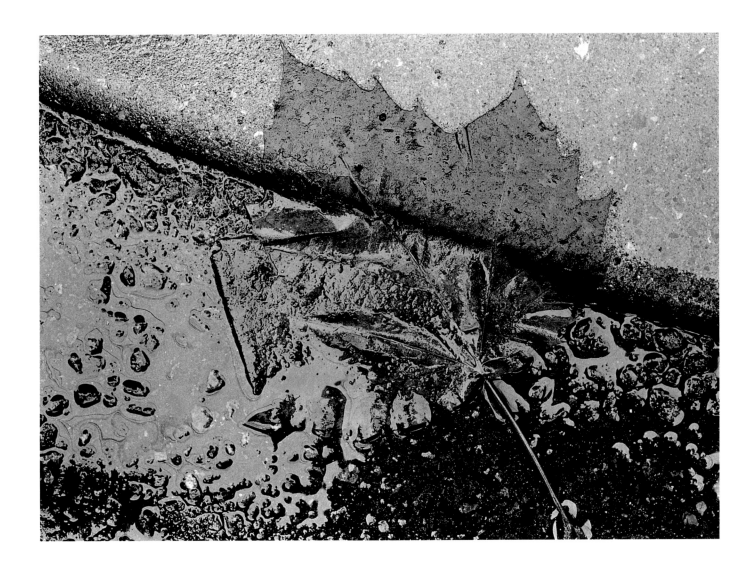

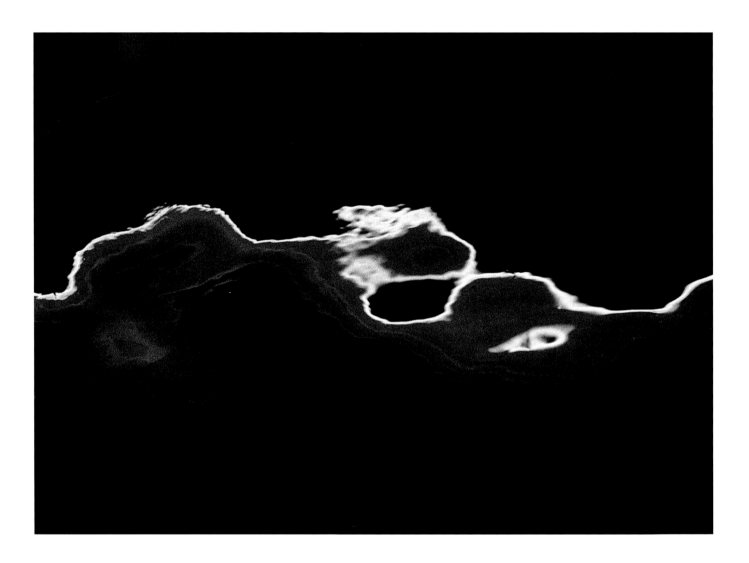

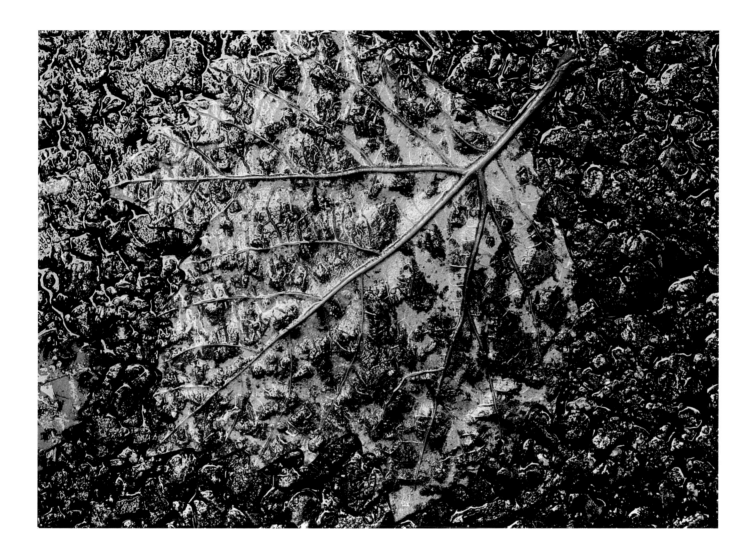

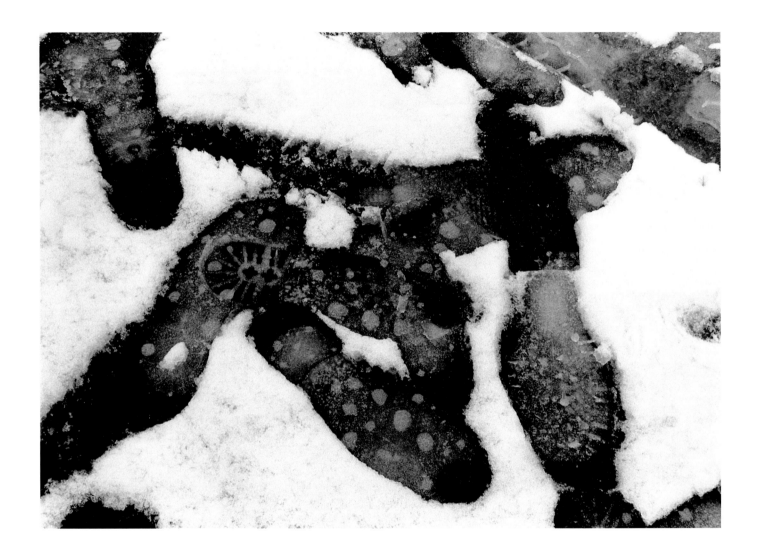